To Ellen with

an

Bob A

Robert Arneson

A Retrospective

Neal Benezra

Des Moines Art Center

This exhibition is funded with generous support from the
Anna K. Meredith Endowment Fund, John and Mary Papajohn,
Des Moines, and the National Endowment for the Arts.

This catalogue is published in conjunction with the exhibition
"Robert Arneson: A Retrospective," organized by the Des Moines
Art Center and presented at the following institutions:

Des Moines Art Center, Iowa
February 8 – April 6, 1986

Hirshhorn Museum and Sculpture Garden, Washington, D.C.
April 30 – July 6, 1986

Portland Art Museum, Oregon
August 1 – September 28, 1986

Library of Congress Catalog Card Number 85-73055
ISBN 0-9614615-1-9

Edited by Lyn DelliQuadri
Designed by Michael Glass Design, Chicago
Typeset by AnzoGraphics, Chicago
Printed by Eastern Press, New Haven

Front cover: *Holy War Head,* 1982-83 [cat. no. 39]

Contents

Foreword

As artistic styles rise and fall at an ever accelerated rate, the underlying issues that shape them frequently linger on long afterward. The great debate over regionalism in the arts has, mercifully, ended. New issues have captured our attention in the past decade, notably the "crafts issue," which is receiving continuous airing by the arts community.

Works made of substances generally identified with the crafts tradition, whether functional or not, have long endured an inferior status in the fine arts hierarchy. Few living sculptors have challenged this condescending attitude in a more outrageous, effective manner than Robert Arneson. As this exhibition documents, he has been the central provocateur and continues to "force the issue" by making the public and the arts establishment, in particular, confront a bias that clay and ceramic sculpture are less than high art. While lingering doubts persist, it is apparent that *media,* as a viable means of classifying art and assessing high-art quality, is increasingly a lame issue.

If fellow Californian Peter Voulkos is the point man of the ceramics sculpture cause, Robert Arneson is one of its most exuberant practitioners and liberating spirits. Together, they have shaped clay into forms and contexts never before realized. Interestingly, clay, along with wood and stone, is the oldest sculpture material, and its innate properties offer endless possibilities as sculptural form and surface. No ceramic sculptor of the current generation has demonstrated the media's many virtues better than Arneson through his technical virtuosity and expressive range.

As a museum of 20th-century art, the Des Moines Art Center is especially pleased to present this nearly twenty-five-year survey of Arneson's sculpture and works on paper, sixty-eight works dating from 1961 to his most recent work. It is appropriate this retrospective be presented in an institution where ceramics and clay sculpture have enjoyed a kinship for thirty-eight years through an artist-in-residence program and with an exceptional ceramic studio designed by Eliel Saarinen, who spent his life fostering the marriage of the fine and applied arts.

This exhibition was jointly conceived by former director James T. Demetrion, and former curator Neal Benezra. As curator of the exhibition, Neal Benezra selected the works and wrote the following catalogue essay. The Art Center is most grateful for his curatorial insights, patience, and professional execution of this important project over a three-year period.

Many Art Center staff contributed time, energy, and expertise towards the realization of the exhibition: Phemie Conner, coordinated packing, shipping, and insurance arrangements; Grace Owens and Jill Downing provided considerable secretarial and proofreading services; Peg Buckely conducted research, particularly through the preliminary stages; Peggy Patrick assisted in numerous areas, from initial planning through the exhibition opening; and the installation, never an easy task when related to sculpture, was most ably executed by Jerry Tow with assistance from Pat Coady, Tom Crowley, Charles Crouch, and Mike Rodriquez.

This exhibition was funded in part by the National Endowment for the Arts, Anna K. Meredith Endowment Fund, and John and Mary Pappajohn. We are grateful that such an enterprise received "partnership" support and especially pleased it culminated on the 20th anniversary of the Arts Endowment; we salute the Agency's financial assistance and leadership role for two decades. Appreciation is extended to the two institutions participating in the exhibition tour; the Hirshhorn Museum and Sculpture Garden and the Portland Art Museum. It is gratifying to have the exhibition tour from one coast to another, and of course, this was only possible through the generosity of the lenders cited on page 102. I wish to personally thank the trustees, past and present, for their support of this ambitious project throughout. Lastly, we all collectively thank Robert Arneson for giving us this opportunity to present his work to the public.

David Ryan
Director, Des Moines Art Center

Acknowledgments

This exhibition was initiated in 1983 by the author and James T. Demetrion, former director of the Art Center. I am deeply indebted to Jim for his confidence in me, as I am to David Ryan, who has enthusiastically supported the project since his appointment as director in 1984. This support became particularly vital after I left the Des Moines Art Center in May 1984 to become Associate Curator of Twentieth-Century Painting and Sculpture at The Art Institute of Chicago.

Robert Arneson's dealers and representatives have been unfailingly helpful throughout the past three years, and I would like to thank Allan Frumkin and George Adams of the Allan Frumkin Gallery; Dorothy Goldeen and Diana Fuller, as well as Lowrie McLean, Nicole Michelson, Chantal Guillemin, current and former exhibition coordinators at Fuller Goldeen Gallery; William and Deborah Struve of Frumkin & Struve Gallery; and Wanda Hansen.

I have benefitted from the enthusiastic support of Price Amerson, Director of the Richard L. Nelson Gallery at the University of California, Davis, who made available important archival materials and tape recorded interviews with the artist. I am also indebted to three of Arneson's peers—William T. Wiley, Roy De Forest, and James Melchert—who, during the course of my conversations with them, helped to fill in historical gaps and personalize my understanding of the art of the San Francisco Bay Area.

I am also very grateful to Lyn DelliQuadri, at The Art Institute of Chicago, who edited this catalogue and nurtured it through publication, and to Michael Glass for his excellent design.

Among many other individuals who have helped me in a myriad of ways, I must mention Suzaan Boettger, Peter Boswell, Byron and Eileen Cohen, Wanda Corn, David Dahlquist, Courtney Donnell, Albert E. Elsen, Deborah Emont-Scott, Nina Felshin, Jonathan Fineberg, George Grant, Andrea Kirsh, Ira Licht, Joan Mannheimer, Byron Meyer, Hal Nelson, John and Mary Pappajohn, Paul and Stacy Polydoran, Joan Simon, Michael McTwigan, Eunice Prieto, Susan F. Rossen, Patterson Sims, A. James Speyer, Gaylord and Vivian Torrence, Joan Wolff, Thomas F. Worthen, Rimas T. Vis Girda, Ian Wardropper, as well as my parents, Morris and Beatrice Benezra.

A simple thank you is not adequate for Maria Makela who is both my toughest critic and my best and most patient friend.

During the past three years, I have had the opportunity to visit with Bob Arneson and Sandy Shannonhouse on several occasions. They have offered the ongoing support and assistance, not to mention hospitality, which is so necessary for an exhibition of the work of a living artist. My reward for much hard work has been their confidence and friendship.

Neal Benezra
Associate Curator of 20th-Century Painting and Sculpture
The Art Institute of Chicago

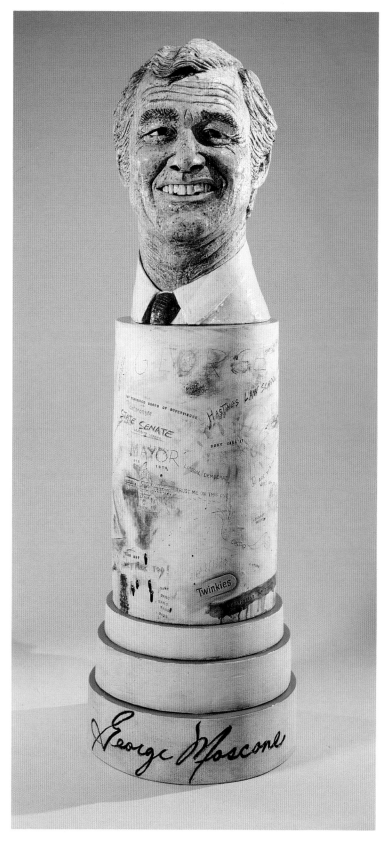

Pl. I. *Portrait of George*, 1981, ceramic, 94 x 29 x 29″. Collection of Foster Goldstrom.

Innocence is bliss. God, I love innocence. One is free. The more one knows, the more one cannot do. And that's basically been my background. I guess I was innocent all along. Of course in ceramics you're not an artist so you're really innocent.[1]

Robert Arneson, 1978

On December 2, 1981, an estimated 20,000 San Franciscans attended the dedication of the Moscone Convention Center, named for the city's recently assassinated mayor, George R. Moscone. Although the center vibrated with music, dance, and the air of civic achievement, there was an undercurrent of tension. Its source was a seven-foot high pedestal bust of the late mayor by sculptor Robert Arneson (pl. I). The artist's larger than life-size image of the slain mayor with lively eyes, a toothy grin, and an unnaturally long neck was on view, but the pedestal on which it rested was conspicuously hidden beneath a red cloth. On that pedestal Arneson had incised graphic references to the mayor's life and his assassination in 1978 — perhaps the most traumatic event in San Francisco's colorful history. At the request of Moscone's widow, city officials, loathe to revive ugly memories, had ordered the pedestal covered.

Two days later, in an editorial titled "Befouling the Moscone Center," the *San Francisco Examiner* stated its dismay in unequivocal terms: "the commission should get the statuary out of the center as quickly as possible and deposit it somewhere out of public view — perhaps in the Bay, at the deepest place."[2] Within days of its unveiling, and at the personal urging of San Francisco Mayor Diane Feinstein, the city's art commission rejected Arneson's *Portrait of George.*

When asked to respond to the decision, Arneson answered with these words:

I should have known better. I've always avoided public commissions before . . . but it seemed they were going to be relatively gutsy, that they wanted a Bob Arneson. And I thought it might be an opportunity — the subject and the place — that something of merit with a cutting edge could be shown. You see, I'm still naive.[3]

The events of December 1981 have profoundly influenced Robert Arneson's view of himself and the purposes of his art. They mark the end of one man's state of grace, of the artistic innocence that the artist describes so wistfully in the words that introduce this essay. Indeed, the innocence with which Arneson has created his at times humorous, at times painfully serious art has engendered an ongoing problematic response to his work. Yet, it was precisely this innocence and a corresponding degree of freedom that allowed him to develop beyond anyone's expectations. Toiling on the fringes of art for a number of years, Arneson perfected his craft, developed a singular vision, and created perhaps the most powerful figurative sculpture of the post-World War II period.

Robert Arneson was born and now resides in Benicia, California, located on the Carquinez Straits, some twenty-five miles northeast of San Francisco. Like the artist, Benicia has known its share of ups and downs. First developed in the early 1840s, the town benefitted from the gold rush as the forty-niners passed through while traveling from San Francisco to the Sierra Nevada foothills. Once California achieved statehood in 1850, Benicia even served briefly as the state capital in 1853; the United States' first West Coast military arsenal was located there soon after. Both town and arsenal prospered through several wars, but when the Pentagon closed the arsenal in 1962, Benicia entered a period of economic stagnation. Fortunately this was relatively short-lived and today Benicia bustles with restaurants and small shops, and is the home to artists Judy Chicago and Manuel Neri, as well as Arneson and his second wife, sculptor Sandra Shannonhouse.

Born in 1930, Arneson recalls a normal and happy childhood, one often punctuated by large gatherings of his father's Norwegian family in Benicia and his mother's Portuguese relatives in nearby Fairfield. He drew constantly and well from an early age and he was encouraged to do so by his father, who, Arneson remembers, was a fine draughtsman. An avid reader of comic books, Arneson made use of cartoon imagery in his early drawings:

. . . in grammar school you see yourself as a hero in various forms and I used to draw from comic books. In those drawings I am sure I was projecting myself in various characterizations.

In one series, the young illustrator actually delineated, in word and image, a full length, play-by-play account of a local high school football game (fig. 1). Even at this early stage, Arneson's manner of drawing and his ability to conceive a series of illustrations were surprisingly well developed. He depicted figures in motion or even in flight, while recording events in the linear, sequential manner of the comic strip, with every play illustrated and keyed to a description below.

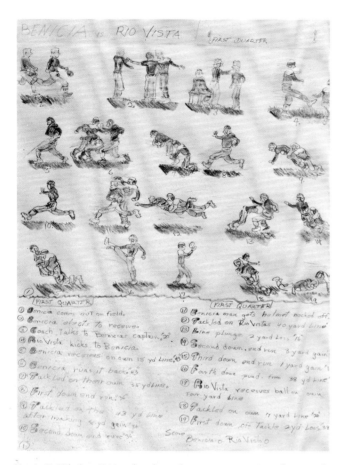

Fig. 1. *Untitled*, c. 1940, colored pencil on paper, 11 x 8½". Collection of Robert Arneson and Sandra Shannonhouse.

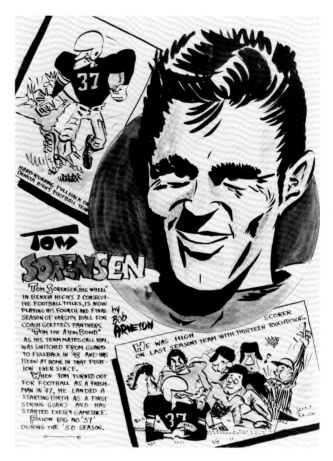

Fig. 2. *Untitled*, c. 1947, ink on paper, 11 x 8½". Collection of Robert Arneson and Sandra Shannonhouse.

By the time he entered high school, Arneson had refined his understanding of the methods of cartooning:

> I was looking at the artistic level of the drawing. I was starting to find that certain people's styles were really very good. One was Al Capp. Terrific linear strength in his drawing. The other one whom I emulated was Milton Caniff who drew *Terry and the Pirates*. I can recall being fifteen years old and actually cutting out a strip he had rendered and laying it out myself. I could figure out the original scale at which they drew and I would lay it out and pencil it in, developing my India ink techniques. . . . I worked real hard teaching myself through comic strips.

Entirely self-taught, Arneson became equally adept with a brush, speedball, and fountain pen. By the age of seventeen, Arneson was seriously aspiring to a career as a professional cartoonist and was contributing weekly sports cartoons to the local newspaper, the *Benicia Herald* (fig. 2). In developing these humorous and laudatory India ink cartoons, Arneson worked from photographs, applying a grid to translate the image to his own drawing. With pen and ink, he heightened the contrast of light and dark by eliminating all grey and integrated a brief description of the individual's athletic achievements into the image. Just as these drawings indicate a tendency to lionize

personal heroes, they are also prototypes in their synthesis of word and image, a method Arneson would later use to enrich both his sculpture and his drawing.

Arneson continued to submit weekly sports cartoons to the *Benicia Herald*—for five dollars per image—throughout the two-and-a-half years he attended the College of Marin in Kentfield. Although he served as sports editor of the college newspaper, these were not auspicious years for Arneson, who missed as many classes as he attended. He had his first introduction to ceramics at the College of Marin and received a rather unpromising D grade. Yet, he apparently showed enough promise as a cartoonist or commercial artist that his instructors at Kentfield sent a portfolio of his drawings to the San Francisco Art Institute and the California College of Arts and Crafts in Oakland. When the latter awarded him a partial scholarship covering tuition, Arneson enrolled there in the spring of 1951.

Arts and Crafts was something of a shock to the aspiring cartoonist. Although committed to a career in commercial art, Arneson soon concluded that he was only an average draughtsman. His sense of discouragement was so strong, in fact, he left school after only one semester to work in an oil refinery. This also proved unsatisfactory and, still intent on a career in art, Arneson chose art education

when he returned to Arts and Crafts in the spring of 1952. Although the wide variety of courses he completed (ranging from the history and philosophy of education to bookbinding, leathercraft, and jewelrymaking) was an excellent foundation for his later public school teaching, Arneson now feels he "cheated" himself out of an education because he never studied painting and sculpture. He did study watercolor, which he claims was the only course that really interested him and in which he excelled.

Arneson was still without artistic direction when he graduated from Arts and Crafts with an art education degree at the age of twenty-three. A competent watercolorist and skilled in a variety of media, he accepted a teaching position at Menlo-Atherton High School, across San Francisco Bay and just minutes north of Stanford University. There he was expected to teach jewelrymaking, architectural draughting, basic design, and ceramics. Ironically, ceramics constituted Arneson's weakest area of training, as he had barely survived the introductory class at College of Marin and had not worked with clay at Arts and Crafts. To develop some basic skills as a potter, he enrolled in a ceramics course immediately after graduation. This experience, much like that of his first commercial art courses, was unsettling:

> My own work was very negligible. I was not a ceramics student, but a student taking ceramics. I was totally incompetent. I never learned to throw. I felt intimidated because everyone could throw well and I was making a fool of myself at the potter's wheel. It was hit or miss and I was always missing.

Although this was Arneson's second false start as a potter, the necessity of teaching ceramics required him to supply his students with classroom projects and technical information, and he soon found himself reading instructional articles written by Carleton Ball for *Ceramics Monthly*. Just as he had taught himself to draw and cartoon, Arneson now spent evenings and weekends learning to throw on a wheel and operate a kiln. "I actually got interested in ceramics while teaching high school," he recalls.

By his own account, by the spring of 1956, his second year at Menlo-Atherton, Arneson was becoming a "proficient" potter (fig. 3). He entered summer school that June, studying ceramics at San Jose State College with Herbert Sanders, a highly respected craftsman known particularly for his work with glazes. Sanders taught in the tradition of Alfred University in New York, which emphasized a mastery of fundamental ceramics technology, sound craftsmanship, and the harmonious integration of form and decoration.[4] Arneson describes his experience at San Jose State as follows:

> I learned how to make a 'well-turned' but basically very dead pot. They were not very lively. You threw a form and the next day you came back and trimmed the entire pot to make it correct, perfect, so that it looked machine-made.

During the second summer session, Arneson returned to Arts and Crafts in Oakland, where his instuctor was Edith Heath.[5] Here he was exposed to an "industrial" approach to ceramics, focusing on an understanding of clay bodies, shrinkage tests, and casting from molds. Although the knowledge he gained would serve him well in

Fig. 3. *Untitled,* 1957, ceramic, 14"h. Collection of Robert Arneson and Sandra Shannonhouse.

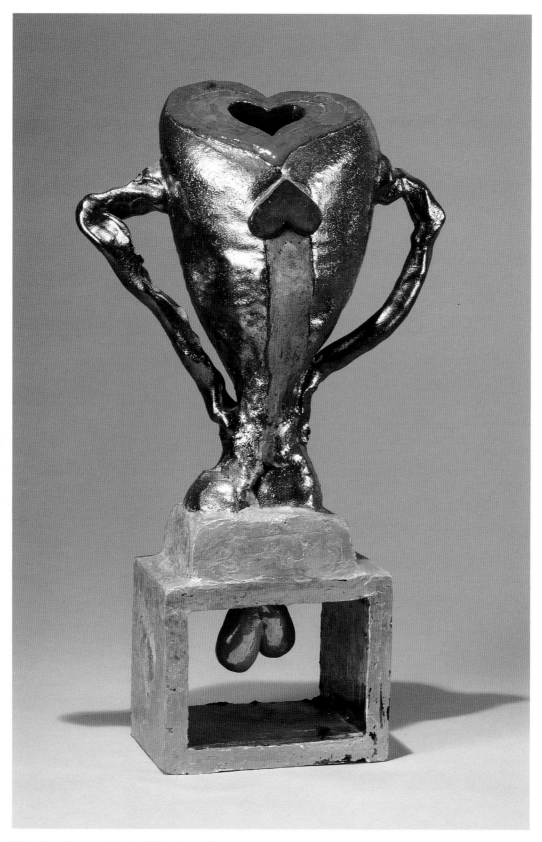

Pl. II. *Heart Memorial Trophy,* 1964 [cat. no. 7].

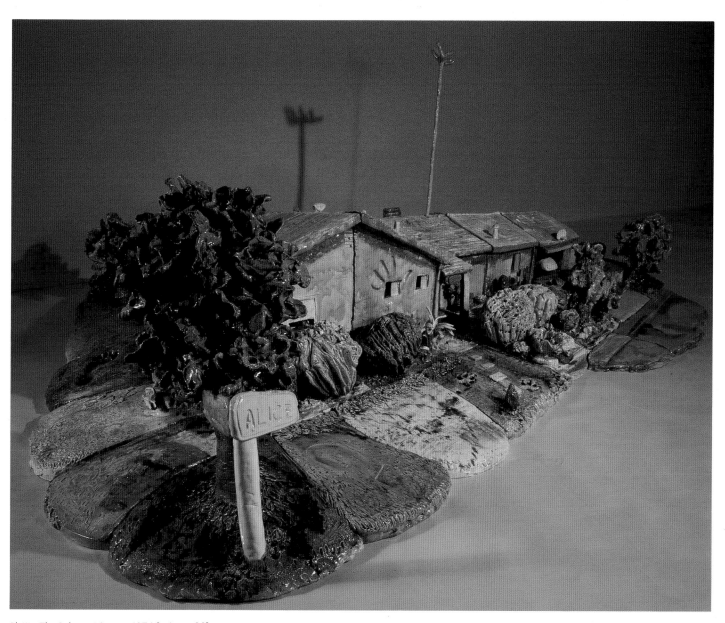

Pl. III. *The Palace at 9 a.m.*, 1974 [cat. no. 20].

later years, Arneson recalls that Heath's rather mechanical approach alienated a number of serious potters, some of whom were moving to Los Angeles to study with a radical young sculptor named Peter Voulkos.

A native of Montana, Voulkos was already developing a reputation as America's foremost young potter when he received an M.F.A. from Arts and Crafts in 1952.[6] Soon thereafter he broke with the purist tradition then dominant in ceramics and began to join wheel-thrown and hand-built pots with little regard for design or decorum (fig. 4). Voulkos's revolt was inspired, to a large extent, by Picasso's work at that time in clay.[7] In the 1940s and 1950s, while working with the French ceramist Georges Ramies at Vallauris, Picasso metamorphosed wheel-thrown forms, often granting them figurative associations and always defying any functional possibility (fig. 5).

Voulkos was perhaps the first artist (not to mention critics or historians) to look seriously at Picasso's ceramics, and he used them as a point of departure for sculpture that was wheel-thrown yet nonfunctional. Whereas the history of functional ceramics demands that form and decoration be considered in tandem, Voulkos instead took great pleasure in spontaneously altering his work, painting the un-even surfaces of his assembled sculptures and, in many cases, accentuating their disjunctions. Just as Picasso integrated the premises underlying painting and sculpture, blurring the distinctions separating these media, Voulkos took clay out of the crafts sphere, creating a new art form whose creative impulse was rooted in progressive developments in painting and sculpture. In so doing, Voulkos challenged the basic foundations on which the ceramics of function and craft have always existed. Subsequent ceramists have been forced either to accept the sculptural premises of his work or to continue as potters in the traditional sense of the word, acceding to the limitations imposed by a wheel.

Between 1954 and 1959, the forum for Voulkos's powerful work and magnetic personality was Otis Art Institute in Los Angeles. There he worked beside students John Mason, Ken Price, Billy Al Bengston, Paul Soldner, and many others, offering them an alternative to the tradition of functional ceramics as it had existed for hundreds of years and as it had been promulgated by graduates of Alfred University since the turn of the century.

One incident in particular illustrates the uproar that Voulkos's work was unleashing in the 1950s, as well as Arneson's view of the

Fig. 5. Pablo Picasso, *Vase Face,* 1947, ceramic, 11″ h. Musée Picasso, Paris. © V.A.G.A., New York.

Fig. 4. Peter Voulkos, *Sevillanas,* 1959, stoneware with iron slip and clear glaze, 56¾ x 27¼ x 20″. San Francisco Museum of Modern Art, Albert M. Bender Collection, Albert M. Bender Bequest Fund Purchase.

medium at that time. In the spring of 1957, Voulkos served as one of three jurors for the Fifth Annual Miami National Ceramics Exhibition. When Paul Soldner and John Mason received two of the top awards, a storm of controversy erupted regarding alleged juror bias, which, in reality, was a thinly veiled attack on Voulkos's work. For several months the pages of *Ceramics Monthly* and *Craft Horizons* were filled with letters that typically described the work of Voulkos and his students as "chunks of stone, badly thrown, badly glazed and badly crafted," and completely missing the point of their work.[8] Interestingly, Arneson contributed to the controversy with this letter to the editor, published by *Ceramics Monthly* in July 1957:

> Concerning the interest created by the 'bacon stealing' of Mr. Voulkos at the recent Miami Show, I should think it would be profitable to print an article on 'What Constitutes Good Pottery,' and have a group of artist-potters contribute their beliefs to this article. It is my own personal opinion that many of these 'new clay forms' belong in the classification of sculpture and not pottery. They should stand on their merits with other clay sculpture and be awarded prizes because of the intrinsic quality, and not because they are *different.*[9]

Arneson clearly recognized Voulkos's ambition. In his formal and conceptual impulse and the scale of his work, Voulkos unreservedly proclaimed himself a sculptor. Despite this insight into Voulkos's frontal assault on the ceramics establishment—an awareness that was exceedingly rare in 1957—Arneson remained squarely in the "good pottery" camp. Speaking in retrospect, Arneson describes himself in 1957 as a "hard core reactionary" and a believer in the "clean pot ethic" that was still very much in vogue.

The year 1957 proved an important one for Arneson. Increasingly serious about ceramics, he abandoned efforts in other media. He continued to read the "how to" articles in *Ceramics Monthly*, no longer for his students' benefit, but now to expand his own mastery of clay. It was also in 1957 that Arneson first saw a Voulkos work in person, and he recalls being "totally impressed and certainly intimidated." Although he considered moving to Los Angeles to work with Voulkos, family responsibilities (Arneson and his first wife Jeanette had a baby son by then) kept him in the Bay Area, where he looked for a place to continue to study. The most vibrant graduate art program on the West Coast was at the San Francisco Art Institute, but that institution did not offer a strong ceramics curriculum until the 1960s. Arneson decided to attend Mills College, a prestigious private school located in the Oakland hills. The ceramics program at Mills had been in the capable hands of Antonio Prieto since 1950. (fig. 6).[10] Spanish born and another graduate of Alfred University, Prieto was a trustee of the American Craftsmen's Council and he became chairman of the Art Department in 1957, the same year Arneson entered Mills. As his Alfred background might suggest, Prieto was well versed in the discipline of ceramics, valuing patience over spontaneity and control over self-expression. While his reputation was as a potter of clearly-designed and delicately-decorated pots, around 1960 Prieto began to experiment with hand-built and assembled sculpture, the best of which was influenced by Joan

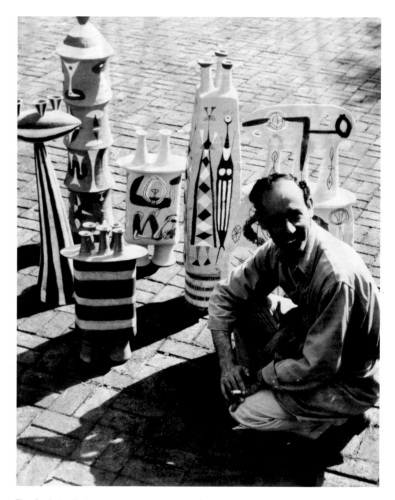

Fig. 6. Antonio Prieto, c. 1960. Courtesy of Eunice Prieto.

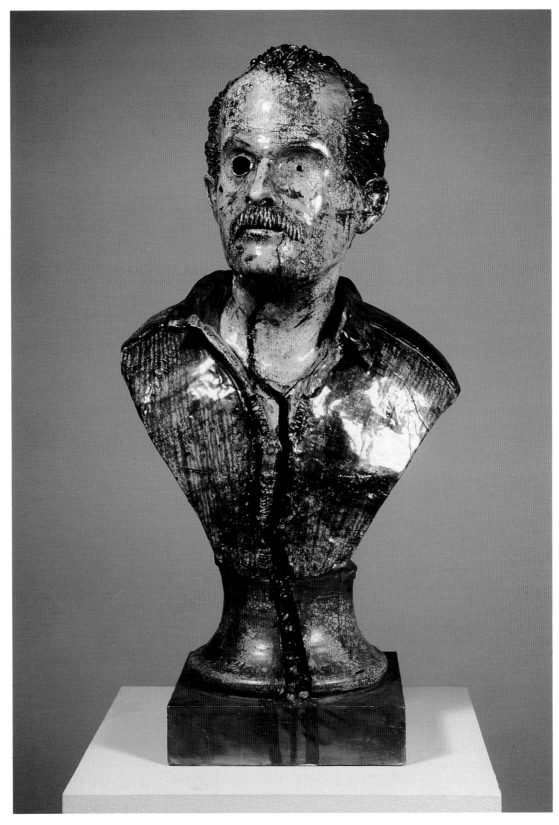

Pl. IV. *Self-Portrait of the Artist Losing His Marbles*, 1965 [cat. no. 9].

Miró. Despite this venture into more sculptural forms, Prieto retained a strong dislike for Voulkos's work and this ultimately became a problem for Arneson.

Arneson spent two years at Mills and rapidly developed into an accomplished potter. His M.F.A. exhibition in the spring of 1958 was dominated by a variety of platters, bowls, and vases, all executed on a wheel and all revealing a debt to Prieto's esthetic (fig. 7). When a particularly accomplished green stoneware vase won second prize in the prestigious Wichita National Ceramics Exhibition that summer, [11] and Arneson accepted a temporary teaching position at Santa Rosa Junior College, he seemed on the way to a moderately successful and quite traditional career as a potter.

While Arneson's work was conventional, his attitude was becoming heretical. His graduate education had afforded him a chance to work full time, but it also had been filled with jarring contradictions causing him to reconsider the assumptions underlying ceramics. Although Prieto chaired the Art Department, Arneson and his fellow potters had been excluded from graduate seminars in painting and sculpture. As Arneson has described it:

> I was a ceramist so therefore I wasn't a fine artist. The ceramists had to sit in the last three rows of the bus and we never got involved in philosophical issues.

This situation might seem an obvious hardship for a young artist-potter, but in Arneson's case it operated to his eventual benefit. Arneson matured in the still wide chasm separating art from craft. Increasingly estranged by temperament from the purist mentality that prevailed among ceramists in the 1950s, he nonetheless worked on the fringes of the "fine arts" until the early 1960s. Ultimately, the contradictions between art and craft that confronted him at Mills proved so jarring that they prepared the ground for his radical and sculptural approach to clay.

As Prieto's example seemed increasingly repressive, Arneson looked to Peter Voulkos, who joined the University of California faculty at Berkeley in 1958. Arneson left his position at Santa Rosa in the spring of 1959 and began teaching high-school art in the Bay Area, which allowed him to closely observe the developments in Voulkos's shop. He remained on the fringes of the movement, never actually working in clay at Berkeley, but he recognized and adopted Voulkos's passionate commitment to art. Beyond the exhilarating atmosphere, Arneson recalls that Voulkos and his students Jim Melchert and Stephen De Staebler were:

> . . . pushing clay beyond its realm. My work always suffered, even when I wanted to be adventurous, because it was too well-made . . . because I was still warped into a pottery-skill mentality . . . throwing too thinly, rather than using the wheel as a building instrument to throw stronger things.

It was at this time that Arneson began to break with the "pottery-skill mentality," producing works of rustic strength that denied functional purposes. These idiosyncratic vaselike forms, their surfaces punctured with numerous spouts, were exclusively stoneware and most were made at the wheel (fig. 8). A few were built by hand and assumed eccentric shapes that only implicitly reveal functional pos-

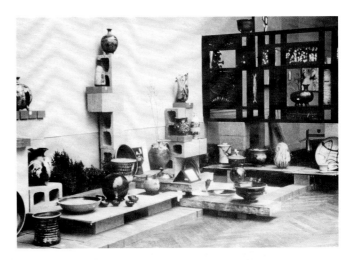

Fig. 7. Robert Arneson's M.F.A. exhibition, Mills College, Oakland, 1959. Courtesy of the artist.

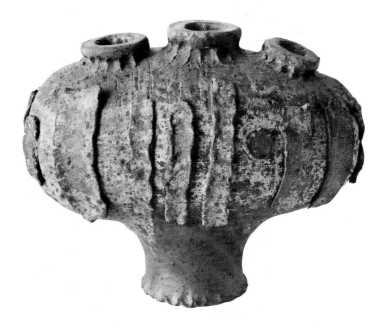

Fig. 8. *Three Spouted Vase,* c. 1959, glazed ceramic, 10¼" h. Minnesota Museum of Art, Endowment Fund Purchase.

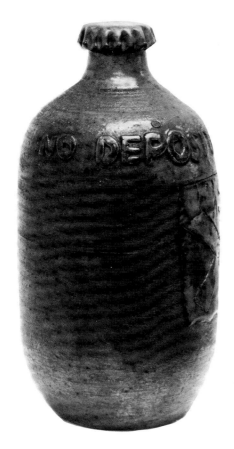

Fig. 9. *No Deposit, No Return*, 1961 [cat. no. 1].

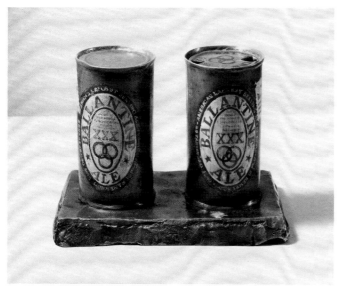

Fig. 10. Jasper Johns, *Painted Bronze (Ale Cans)*, 1960, bronze, 5½ x 8 x 4¾". Ludwig Collection, Kunstsammlung Basel.

sibilities. Perhaps more exciting in light of Voulkos's work were several vertical pieces, some reaching three to four feet in height and resembling plantlike forms.

Arneson's works—ranging from small, correctly thrown and delicately glazed vases and bottles to large, ruggedly sculptural pots—were shown in September 1960 at the Oakland Museum. The museum's bulletin noted that the show of twenty-six works, "originally planned as a pottery exhibition," turned out to be "more of a sculpture show."[12] The perceptive historian and critic Alfred Frankenstein responded favorably to Arneson's work, describing the young artist in *Art in America* as "continuing the inventive tradition of Bay Area ceramics, beginning with pot-like shapes that take on organic qualities as they are worked. . . ."[13] Arneson's own recollection of this period reveals an increasing confidence in himself and his work:

> I was in my 'organic' period, quasi-Voulkos, but the work was more organic, ripped and torn, cubistically structured, and for the most part sculpture and not pottery. I was feeling very good about what I was doing and I thought I was an artist. I was going to be an artist and not a potter in 1960.

As Arneson moved increasingly toward an Abstract-Expressionist sculptural style, an estrangement developed with his erstwhile mentor Prieto. Arneson had joined the Mills faculty to teach design and basic crafts in the fall of 1960. Arneson's introduction of the work of Robert Rauschenberg at Mills troubled Prieto, but more problematic was the strong psychological impact he exerted on the graduate ceramists while working beside them at night. Eventually Arneson worked in the Mills ceramics shop only when Prieto was away. A final break occurred in the summer of 1961:

> One afternoon in early September, while demonstrating pottery techniques at the California State Fair along with Tony Prieto and Wayne Taylor, I threw a handsome, sturdy bottle about quart size and then carefully sealed it with a clay bottle cap and stamped it *NO RETURN*.[14]

Although produced spontaneously, *No Deposit, No Return* (fig. 9) is Arneson's first important work, one that is historically significant and that signaled his break with the ceramics establishment. *No Deposit, No Return* is contemporary with Jasper Johns's *Painted Bronze (Ale Cans)* of 1960 (fig. 10), and both works were born of humor and anecdote (the idea to sculpt two Ballantine ale cans was suggested to Johns by Willem de Kooning's comment that Leo Castelli could sell anything—even two cans of beer). The question of creative primacy is an open one, as Arneson notes:

> Living in San Francisco, you saw only reproductions and this was probably even so with the beer bottle I made at the California State Fair. I don't know, I want to maintain innocence on this because we all know that Jasper Johns did the famous beer cans of 1960. And I confess that I looked at *Artnews* and he may have been reproduced and that may have given me the impetus, but I can't honestly say that I remember. I would love to have been innocent and just have discovered it on my own terms. But

Fig. 12. *Noble Image*, 1961 [cat. no. 3].

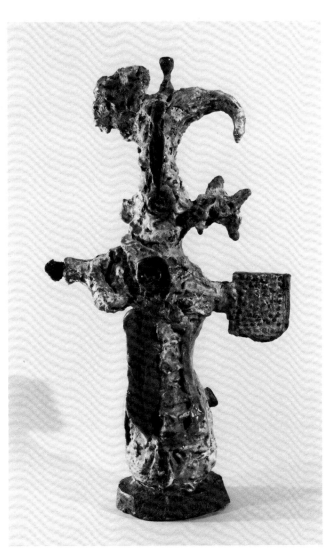

Fig. 11. *Sign Post*, 1961 [cat. no. 2].

Fig. 13. *Untitled*, 1963 [cat. no. 4].

looking back, one can't be innocent because of the nature of reproductions.

Although Arneson was certainly conversant with Johns's work at that time, it is noteworthy that *Painted Bronze* was not illustrated until the winter of 1962, eighteen months after Arneson made *No Deposit, No Return*.[15] The question of Arneson's possible debt to Johns and the Pop art esthetic aside, *No Deposit, No Return* is more important as a rejection of the ceramics establishment that confronted Arneson on a daily basis. By placing a ceramic cap on a wheel-thrown bottle, Arneson unconsciously closed the door on the traditional use of clay strictly for the production of functional objects.

Despite the importance of *No Deposit, No Return* as a harbinger of Arneson's so-called "Pop" imagery of the mid-1960s, it was, in fact, an aberration in his work at that time. During that same summer Arneson produced another body of work, of which *Sign Post* and *Noble Image* (figs. 11 and 12) are particularly impressive examples. In their figurative reference and vivid use of color, each testifies to the richness of Arneson's work and the multitude of his sources, including ancient Japanese funerary sculptures called Haniwa:

> I narrowly defined my forms to a vertical and these forms would take on an iconography that . . . looking back on it would be a Haniwa. I would branch off of a tree-like form and use a graphic, inscribed mark on the wet clay. Then I would fire it and look at it and say—it needs a little articulation with color.

Arneson's interest in Haniwa sculpture at this time is significant because Avery Brundage donated a particularly fine work of this type to

the city of San Francisco in 1960, and it went on view at the De Young Museum soon after its acquisition (fig. 15).[16]

Yet Arneson's predominant source for those vertical works was unquestionably Miró, whose ceramic sculpture had gained wide currency among progressive sculptors by 1960.[17] Through his collaboration with the Spanish craftsman Artigas from 1953 to 1956, Miró achieved brilliant and effusive color and line, qualities formerly outside the sphere of ceramic sculpture. He elicited figurative associations while simulating the rough-hewn textures of the rocks and fossils he found near Artigas's studio in Gallifa. Like Miró, Arneson approached clay as a two-dimensional surface to be painted. The vertical form, idiosyncratic profile, and clear distinction between front and back of Arneson's *Sign Post* reveals a particular debt to Miró (fig. 16). More important than this formal affinity to the work of the Spanish artist was a Surrealist edge that Arneson's sculpture began to assume for the first time:

> You would allow the clay to talk to you a little bit. Instead of Voulkos—just pure gut action, response to the clay, slap-bang, poke a hole, rip and tear—you also alluded to a subliminal type of imagery which crept through.

Despite his own interest in Miró, Prieto criticized this direction in Arneson's work. He frowned on the spirited play that resulted in *No Deposit, No Return* and when Mills reopened in the fall of 1961 the older artist and his former protégé were scarcely speaking. Perhaps the final straw was the illustration of one of Arneson's "organic" vase sculptures in Rose Slivka's pioneer article "The New Ceramic Presence" in that summer's issue of *Craft Horizons*.[18] In chronicling

Voulkos's development of Abstract Expressionism in ceramic sculpture, Slivka included the work of Arneson and two other Mills graduates Harold Myers and Win Ng, along with John Mason, James Melchert, and numerous others. Arneson's relationship with Prieto became so strained that he briefly abandoned clay altogether to devote himself to drawing and newspaper collage (fig. 17).

In 1962, when his second museum show "Robert Arneson: Ceramics, Drawings and Collages" opened at the De Young Museum in San Francisco, Arneson could no longer conceal his revulsion with the ceramics establishment. A new work, *Eviscerated Pot*, clearly revealed Arneson's impatience with the sensibility that Prieto personified. The brown stoneware vase bears a bloody red wound, symbolic of the artist's assault, and unequivocally declares Arneson's independence: There could be "no return" to traditional forms. Within months, he had left Mills College and was teaching at the University of California, Davis, where he has conducted his campaign ever since.

The town of Davis and the University of California campus that it houses typify an aspect of the state's rural life that is relatively unknown outside the West. At some distance from Los Angeles and San Francisco, Davis is small and quiet and maintains immense civic pride in the quality of life it offers. For several decades, the campus has served as the agricultural arm of the state's university system, with strong programs in veterinary medicine and, more recently, in enology and viticulture. One might expect art to be peripheral in these surroundings and indeed it was for several decades; the first courses were offered in 1953 and a major was not established until four years later.[19] Three painters and sculptors held joint appointments in the Department of Art and in the Department of Home Economics, accurately reflecting the fledgling status of the art program in 1960. Rather than a hinderance, the newness of the program proved congenial. The absence of established personalities and procedures enabled the young and forceful artists who came to Davis between 1960 and 1965—among them painters Wayne Thiebaud, William T. Wiley, and Roy De Forest and sculptors Manuel Neri and Arneson—to develop the most dynamic university art program in the West. The experience, as described by Arneson, was a long and fruitful one:

> I was surrounded by all these artists who contradicted each other, and it just made a beautiful, stimulating atmosphere. Wiley's ideas were very stimulating for me because they instilled a support system. I was not receiving too many compliments at that time and Wiley came along and said 'you've got to learn to trust yourself.' De Forest was a beautiful antidote for Wiley with another kind of personal vision. I have to speak also of Wayne Thiebaud, who had a very classic, poetic view, a sense of color and was a remarkable teacher.[20]

Arneson was hired in 1962 to teach design in the College of Agriculture (which he did for three years) and to develop a program in

Fig. 14. *Study for a Gargoyle,* 1963 [cat. no. 5].

Fig. 15. Haniwa Warrior, c. 6th century, earthenware, 47½″ h. Asian Art Museum of San Francisco, the Avery Brundage Collection.

Fig. 16. Joan Miró, *Figure with Arms Up,* 1955-56, ceramic, 7½″ h. Courtesy of Pierre Matisse Gallery.

Fig. 17. *Untitled*, 1961 [cat. no. 43].

ceramic sculpture for the Art Department. The ceramics studio was and still is housed in a large corrugated metal building, and although Arneson's ceramics program now fills the entire building, in 1962 only a small portion of the space existed for ceramics and for a foundry that Arneson assisted sculpture professor Tio Giambruni in constructing.[21]

Arneson's next significant work evolved during the summer of 1963 when he was selected to participate in "California Sculpture," an exhibition held on the rooftop garden of the Kaiser Center in Oakland and curated by Paul Mills, Walter Hopps, and John Coplans.[22] The list of 32 sculptors—including Edward Kienholz and Simon Rodia, as well as Voulkos, Mason, and Neri—was quite impressive, and Arneson was flattered but also anxious about the opportunity:

> This really created an awakening in me because suddenly I had to present myself with my colleagues and how was I going to stand up against them? I could see myself, Bob Arneson, between John Mason and Peter Voulkos and would I be just a junior version of those two? I really put my mind together and reflected back on my heritage as a ceramist—somebody who dealt in reproduction. I really thought about the ultimate ceramics in western culture . . . so I made a toilet and cut loose and let

every scatological notation in my mind flow freely across the surface of that toilet.

The result was *Funk John* (fig. 18), Arneson's first controversial sculpture and the only important example of his work to have been subsequently destroyed. Photographs show that the work was a misshapen toilet, roughly surfaced and covered with numerous scatological references on the exterior of the tank and in the bowl. Realizing that the fabricated excrement ("ceramic emblems," as Arneson terms them) might be offensive, the artist placed the work on stacked concrete pads so it stood well above eye level. After installing the piece, however, Arneson received a call from John Coplans, who had been directed by a Kaiser executive to remove it. Arneson acceded to the request the following day, and while he was very annoyed by the experience, he was simultaneously pleased, feeling he had "finally made a Bob Arneson, finally arrived at a piece of work which stood firmly on its own ground."[23]

Funk John was of enormous importance for Arneson, providing the impetus for a series of works that interpreted various types of household objects. This body of work, which predominated throughout the mid-1960s, included *John with Art,* 1964 (fig. 19), *Heart Memorial Trophy,* 1964 (pl. II), and *Call Girl,* 1966 (fig. 20). Of these works, *Heart Memorial Trophy* is the most emphatic, as the

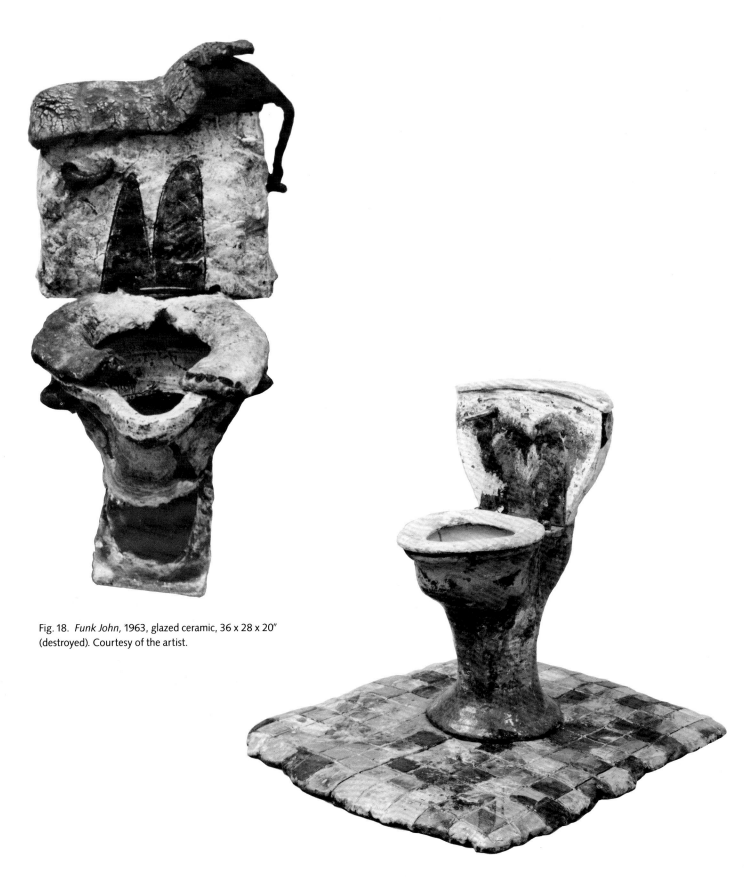

Fig. 18. *Funk John,* 1963, glazed ceramic, 36 x 28 x 20″
(destroyed). Courtesy of the artist.

Fig. 19. *John with Art,* 1964 [cat. no. 6].

heart is complete with human appendages and genitals, all mockingly formed and brilliantly glazed. By the mid-1960s, Arneson was consciously rebelling against all standards of good taste in art; wit, satire, and irony became weapons in his arsenal.

Funk John occupies an important position, not only for Arneson, who calls it his first mature work, but also for the history of art in the San Francisco Bay Area.[24] Since the late 1940s, when Clyfford Still and Mark Rothko taught at the California School of Fine Arts (now the San Francisco Art Institute), the region had been preoccupied with expressionism, both abstract and figurative. The legacy of these two artists is complex and extends far beyond the formal tradition of Abstract Expressionism. Still and Rothko had lived on the West Coast and, even though their most important work was done in New York, they continued to harbor a well-known antipathy to the art institutions of the East. Feeling themselves at best misunderstood and at worst ignored, Still and Rothko implored their protégés to trust their impulses and free themselves of the dogmas and expectations of the contemporary art world. Their ideas found ready adherents in Bay Area students, who, despite never having experienced rejection in New York, felt slighted by the lack of an art public in San Francisco at that time. Perhaps without intending it, Still and Rothko bred an attitude of iconoclasm among San Francisco artists.[25]

By the late 1950s, the Abstract-Expressionist tradition—experienced vicariously after Still returned to New York in 1950—was essentially spent. But the iconoclasm survived and, ironically, it was soon directed against the movement which spawned it. Thus, William T. Wiley described Abstract Expressionism as:

> . . . revolutionary in its way, but it became a heavy moral trip. If you drew a line it had to be grounded in God's tongue or the core of the earth to justify putting it there.[26]

While adopting the self-conscious individualism that Still, in particular, had implanted in the Bay Area, Wiley, Arneson, Robert Hudson, Roy De Forest, and others rejected Abstract Expressionism and assumed, instead, an ironic attitude toward art and life. They created "Funk" art, as it came to be called, and their playful impudence and often crude manipulation of materials prevailed until the mid-1960s.[27]

Robert Arneson's early sculpture, and particularly *Funk John*, evolved in this climate. As a new faculty member at Davis, Arneson found strong support for his campaign against craft, and Wiley's advice to "trust yourself" was of special importance in these early years. Arneson also was fascinated by the shock value possible in Funk art—recalling that even he was "jolted" by *Funk John*[28]—and recognized the potentially extraordinary psychological effect of carefully chosen and aggressively handled objects. Thus, while such ceramic sculptors as Melchert and Arneson remained somewhat outside the "fine art" mainstream, even in the Bay Area, they were unquestionably affected by contemporary developments in the region. Just as painters Wiley and De Forest overcame the example of Abstract Expressionism, Arneson now rejected the pioneering work in clay of Peter Voulkos. In Melchert's words, Voulkos had given younger artists "permission to think for themselves;"[29] yet, Arneson felt compelled to introduce outrageous subject matter into his art as one way of transcending Voulkos's imposing example.

Fig. 20. *Call Girl*, 1966 [cat. no. 11].

Arneson's use of household objects as subjects for sculpture in the early 1960s engendered numerous misconceptions linking the artist to the Pop art of Claes Oldenburg, Roy Lichtenstein, and others. In fact, any relationship was tangential; Arneson's interpretation of a toilet is more expressive in a visceral sense than Oldenburg's *Soft Toilet* of 1966 (fig. 21). For Oldenburg and many Pop artists, the witty choice of an object for humorous artistic reconstruction provided an end in itself, while Arneson selected common objects for their allusive potential, particularly when submitted to his ravaging hand.

It is equally misleading to associate Arneson's *Funk John* too closely with Marcel Duchamp, whose *Fountain* of 1917 (fig. 22) operates on a strictly intellectual level and bears none of the gutsy expressiveness of Arneson's work. *Funk John* and Arneson's subsequent toilets are perhaps closest to Oldenburg's early work, particularly the obsessive *Ray Gun* images from 1959 and 1960 (fig. 23). In these works, Oldenburg drew upon objects and human anatomy, yet each was ultimately vulgarized by the artist's mocking attitude and inelegant treatment of materials, and both characteristics are apparent in Arneson's work. The fact that a toilet is, as Arneson terms it, "the ultimate ceramic," multiplies its references and aids in the artist's humiliation of the pottery establishment.

Until this time, Arneson, like most of Voulkos's followers, had worked almost exclusively in stoneware, a material consistent with the Japanese tradition that yields rather heavy, monochrome surfaces. Having recently abandoned abstraction, he now considered these rather unexciting colors inadequate. To enhance the new-found edge of his sculpture, Arneson began to experiment with white earthenware clay and the brilliant low-fire glazes that Melchert and Ron Nagle were using at the San Francisco Art Institute. He came to conceive of the white clay as a ground for painting and of ceramics as polychrome sculpture. Thus, he abandoned the romantic, "response to the clay" manner of Abstract Expressionism in favor of a more colorful, playful approach to sculpture, in which both a mastery of glazes and the act of painting became an integral part.

Whereas *Funk John* lacked bold surface articulation, *Toaster,* 1965, and *Typewriter,* 1966, are remarkably immediate (figs. 24 and 25). The latter, a watery green and yellow portable typewriter with bright red finger nails instead of keys, reveals Arneson's new interest in color. With works such as this, Arneson approached the wit and subtle humor of Man Ray and Magritte, abandoning the anxiety of *Funk John* in favor of a delightful application of color that heightens both the sensuousness of the surface and the humorous, *trompe l'oeil* character of the object. Ultimately, Arneson's return to ceramic craft helped to establish a balance between the varied impulses that would govern his art until 1981: humor, virtuoso technical achievement, and an ongoing dialogue between painting and sculpture.

Throughout these years Arneson lived in a house in Davis, at the corner of Alice and "L" Street (fig. 26). A standard "ticky-tacky" tract house, "Alice," as Arneson called it, assumed a persona for the artist in the mid-1960s and became the subject of a body of work ranging from drawings (fig. 27) to monumental sculpture. In part this de-

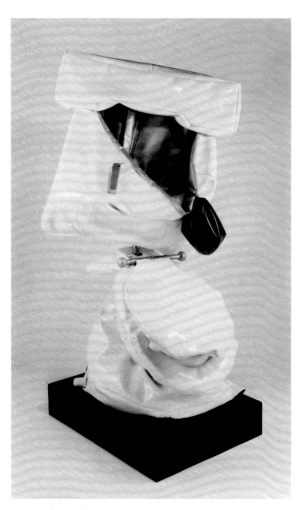

Fig. 21. Claes Oldenburg, *Soft Toilet,* 1966, vinyl, kapok, latex, and wood, 52 x 32 x 30″. Whitney Museum of American Art, gift of Mr. and Mrs. Victor W. Ganz.

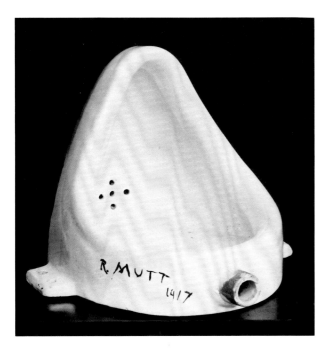

Fig. 22. Marcel Duchamp, *Fountain*,1917 (#2, 1952), ceramic, 24" h. Courtesy of Sidney Janis Gallery.

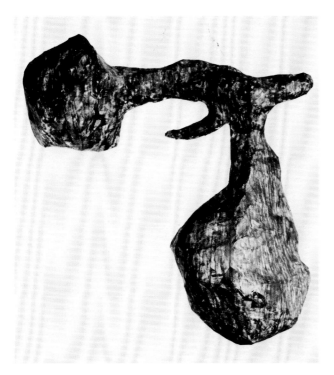

Fig. 23. Claes Oldenburg, *Empire ("Papa") Ray Gun*, 1959, casein, newspaper, and wire, 35⅞ x 44⅞ x 14⅝". Museum of Modern Art, gift of the artist.

veloped out of Arneson's obsession with synthesizing painting and sculpture and making landscape studies in clay. Arneson applied one-point perspective and foreshortening to compress and flatten his sculpture, in contrast to the tradition of representational, two-dimensional art that employs these devices to create an illusion of depth.[30] For example, *Box House Landscape* (fig. 28) is a small model of "Alice" and her surroundings in the form of a miniature house with steeply-pitched sides. On it, Arneson incised the contours of forms and applied vivid glazes. The sides of the sculpture echo the receding planes of the walls and streets, thus affirming in three dimensions the forms that the artist depicts graphically in line and color. The most monumental of the "Alice" works are *Big Alice Street,* 1966, an enormous replica of the house, remade in 1974 under the title *The Palace at 9 a.m.* (pl. III); and *Alice House Wall,* 1967, a free-standing relief wall. In order to build these extremely large works, Arneson employed a system of modular building blocks, a device that rarely had been used by ceramic sculptors since the Della Robbias in the fifteenth century.[31] In the case of *Alice House Wall,* which stands nearly five feet high and six-and-a-half feet long, Arneson glazed each of the thirty-seven modular blocks a different color, creating a bright, two-dimensional pattern of color and shape that balances the work's sculptural size and the mass of the component parts.

The notion of compressing sculptural space had far more complex results in *The Palace at 9 a.m.,* which rests on a table-top pedestal similar to an architectural model. Arneson made "foreground" objects—the street sign and tree—proportionately larger than those in the "background," thereby assuming a stationary position for the viewer directly in front of the street sign. Arneson's attempt to synthesize two-dimensional illusion with the demands of three-dimensional sculpture had formal shortcomings. For example, the receding scale does not allow for effective alternate viewpoints because of the skewed proportions. Yet, the artist's wit was, as always, razor sharp.

Arneson spent the academic year 1967-68 in New York with a fellowship from The Institute of Creative Arts, University of California, and saw two exhibitions at the Museum of Modern Art that were of particular importance for the development of his work: "The Sculpture of Picasso", 1967-68,[32] and "Dada, Surrealism and Their Heritage", 1968, in which his *Typewriter* was included. In the latter exhibition, Arneson saw Giacometti's *The Palace at 4 a.m.,* 1932-33 (fig. 29), and he could not resist satirizing Giacometti and his own suburban domicile by remaking and retitling his earlier *Big Alice Street.*

By the time he returned to California in the fall of 1968, Arneson had achieved a measure of success as an artist and as an instructor, and young ceramists were enrolling at Davis specifically to work with him. He maintained close personal and professional relationships with numerous students, among them David Gilhooly and Richard Shaw, and they often exhibited together and traveled to San Francisco to visit galleries and museums. In this sense, Arneson had assumed Voulkos's mantle as the leading ceramic sculptor and instructor of the period, and his rapport with his students might be compared with Voulkos's a decade earlier.

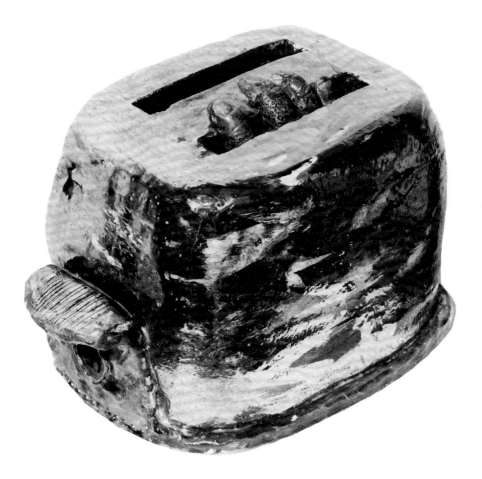

Fig. 24. *Toaster*, 1965 [cat. no. 8].

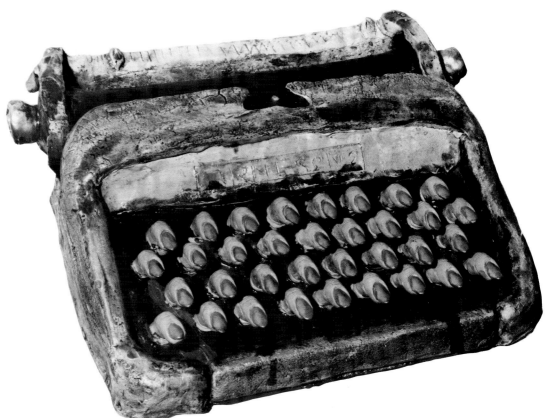

Fig. 25. *Typewriter*, 1966 [cat. no. 12].

In his teaching, Arneson has consistently mocked traditional ceramic instruction, emphasizing instead the painterly and sculptural potential of clay.

What was going on in ceramics at Davis was a mild revolution. My concern, my purpose as a teacher, was to treat ceramics as an art and this meant we had to deal with ideas and content. I am not concerned with process in the craft tradition. I was really concerned with color and in 1965 I started using only white clay in my teaching so my students had to approach ceramics as a painting process.

To free his students from what he terms the ceramist's traditional "Calvinist obligation to make something useful," Arneson often assigned interesting and rather daring projects. For example, he might ask his students to build a form and then destroy and rebuild it "just to get away from the mystique, the preciousness" of ceramics.

Following his return from New York, Arneson explored various aspects of the ceramic tradition, working against this tradition for stimulation. He cast small objects in porcelain and then finished them with the same celadon glazes as Sung potters had used centuries earlier in China; he made ceramic bricks ("the clay brick as the building stone of western civilization"); and he threw teapots that bore erotic appendages and orifices. Despite his growing reputation as a teacher and ceramist, and despite the fact that his series of *Sinking Brick Plates* were included in the 1970 Whitney Biennial, Arneson's work of the late 1960s is generally less ambitious in form, scale, and content than the earlier "Johns" and "Alice" pieces. His anti-ceramics rhetoric to the contrary, Arneson had become something of a captive of that very tradition. He had sacrificed risk for didactic whimsy and was unable to achieve the powerful forms that might transcend the fragility of his material.

The late 1960s were years of personal retreat, as well. By 1969 Arneson's marriage was faltering seriously and he had begun to date a former Davis student, Sandra Shannonhouse, whom he married four years later. As a form of therapy, Arneson even sought refuge in craft, spending an entire summer making 3,000 ceramic tiles that he then installed in his house. This effort ended in near-tragedy on December 17, 1969 when the gasoline Arneson was using to remove the existing vinyl floor exploded in flames and "Alice" suffered extensive smoke damage. Although the house was completely restored, the fire was something of an omen, and the following year Arneson took a sabbatical leave. Putting some distance between himself and his life in Davis, he moved back to his childhood home Benicia. Within a year he divorced, gained custody of his four sons, and pursued a radically new direction in his art.

Throughout the 1970s, Arneson concentrated on portraiture—offering both his own likeness in a number of *guises* as well as images of artists who influenced his thinking. While he took considerable pride in mastering this time-honored form, particularly in the renegade material of clay, Arneson came to portraiture virtually by accident.

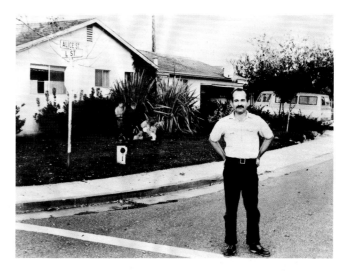

Fig. 26. Arneson standing in front of his house at 1303 Alice Street, Davis, California, 1967. Courtesy of the artist.

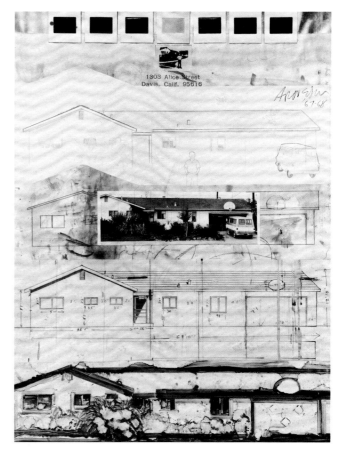

Fig. 27. *1303 Alice Street (Working on Alice)*, 1967-68 [cat. no. 47].

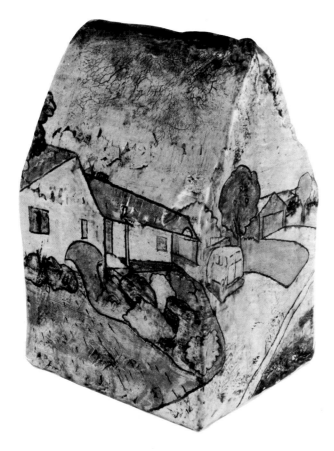

Fig. 28. *Box House Landscape with a View of Alice and "L"*, 1966, glazed ceramic, 15 x 11 x 9½". American Craft Museum, gift of the Johnson Wax Company.

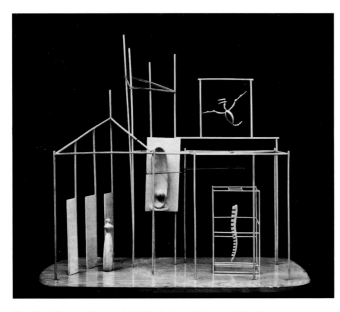

Fig. 29. Alberto Giacometti, *The Palace at 4 a.m.*, 1932-33, wood, glass, wire, and string, 25 x 28½ x 15¾. The Museum of Modern Art.

His first project upon returning to Benicia was a series of "Dirty Dishes", ceramic meals on plates that were richly colored with china paint and derived from the painting of Arneson's colleague Wayne Thiebaud. While these works continued his former direction, Arneson soon expanded the concept into a full-scale tableau, *Smorgi-Bob, the Cook*, 1971 (fig. 30). Here Arneson's manipulation of perspective for sculptural purposes is highly accomplished; he constructed a steeply pitched table-base that gives the illusion of depth despite its compressed form. Overflowing with every conceivable foodstuff, the smorgisbord forms a symmetrical, receding composition. Upon its completion Arneson realized:

> . . . that if I added another element in the back I could have a perfect triangle, so I included myself as a chef, honoring myself as a ceramist, a man of baked goods.

While in retrospect *Smorgi-Bob* was Arneson's first major self-portrait, it was not his first such work. He had fashioned busts of himself as early as 1965 on large aluminum "coins" (fig. 31), and in the form of an initially rather undistinguished, generalized likeness above a tabletop pedestal. When the latter bust cracked from lip to base in the kiln, the ever resourceful Arneson epoxied a cascade of marbles in the split and titled the result *Self-Portrait of the Artist Losing His Marbles* (pl.IV).[33] Despite the success of that work, Arneson did not immediately recognize the possibilities of the new form and did not make another self-portrait until *Smorgi-Bob*, six years later.

Arneson intended to paint *Smorgi-Bob* in his customary fashion, but its promised inclusion in a major exhibition shortly after its completion in the fall of 1971 made this impossible. That exhibition, "Clayworks: 20 Americans," held at the Museum of Contemporary Crafts in New York City, established Arneson nationally as the leader of the ceramic wing of the Funk movement. Representing this group were such artists as Melchert, Shaw, and Gilhooly, as well as Marilyn Levine, Chris Unterseher, Peter VandenBerge, and Patti Warashina. Significantly, *Smorgi-Bob* was the largest and, in fact, the only monumental work in the show, which included numerous cups, plates, figurines, and other humorous yet ultimately slight objects. Writing in the *New Yorker*, Janet Malcolm accurately described Arneson as the *doyen* of the movement, and this term was not lost on Arneson, who used it as the title for a self-portrait completed the following year.[34]

If *Smorgi-Bob* brought Arneson renewed prominence, it also spurred his confidence and ambition and he again began to press clay beyond its former applications and possibilities, both in scale and esthetic effect. In 1971-72, he completed no fewer than eighteen self-portraits. These consistently accomplished works, rendered with the authority one might expect from the *doyen* of the clay sculpture movement, were exhibited at Hansen Fuller Gallery in 1972:

> That is where my obsessiveness came through. Eighteen self-portraits. I think some of them remotely resemble the German eighteenth-century artist Messerschmidt, who did psychotic self-portraits screaming and grimacing [fig. 32]. Working in clay, I could get that full, robust color . . . they really came off as lively

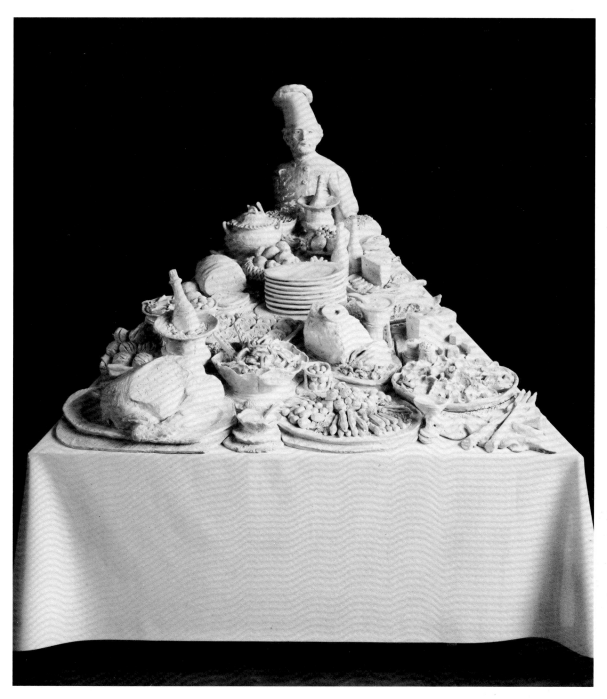

Fig. 30. *Smorgi-Bob, the Cook,* 1971 [cat. no. 14].

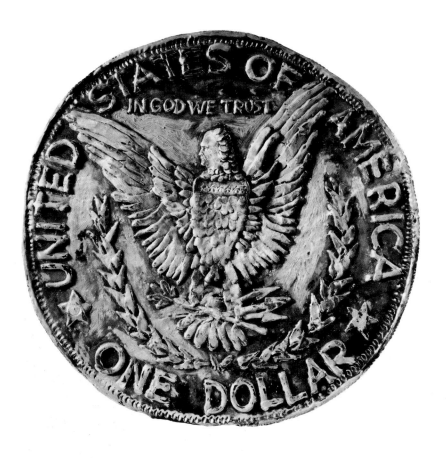

Fig. 31. *Two-Bit Artist*, 1965 [cat. no. 10].

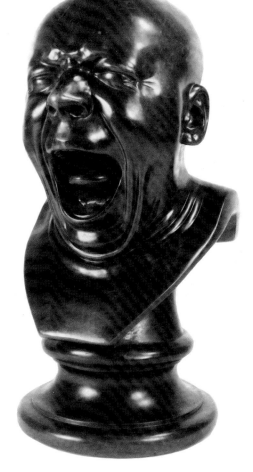

Fig. 32. Franz Xavier Messerschmidt, *The Yawning One*, c. 1770-83, bronze, 16¾" h. Collection of Allan Frumkin, courtesy of the David and Alfred Smart Gallery, The University of Chicago.

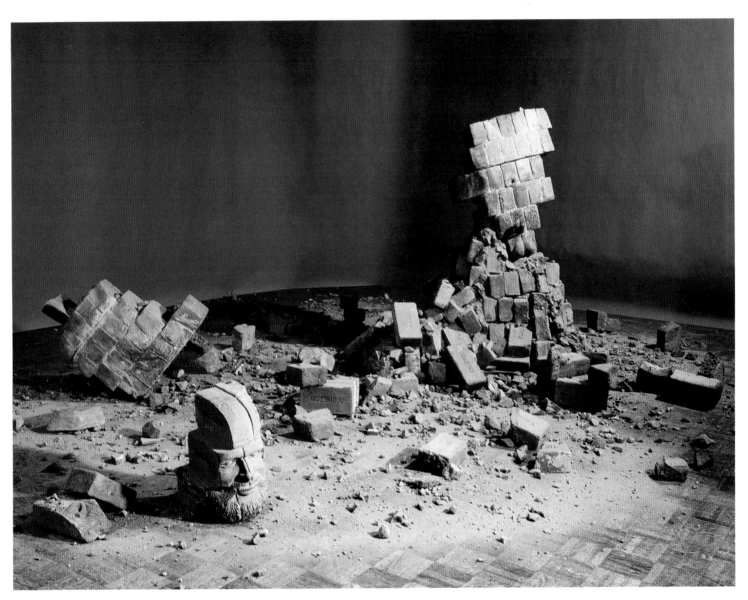

Pl. V. *Fragment of Western Civilization*, 1972 [cat. no. 16].

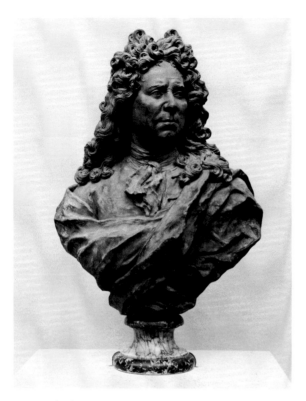

Fig. 33. Charles Antoine Coyseveaux, *Self-Portrait*, c. 1702, terracotta, 28 x 20 x 12½". The Fine Arts Museums of San Francisco, gift of Mr. and Mrs. Grover Magnin.

Fig. 34. *Untitled*, c. 1965, ink on paper, 11 x 8½". Collection of Robert Arneson and Sandra Shannonhouse.

works. They also brought me into a structure—portraiture and self-portraiture.

In contrast to the generalized form that characterized *Self-Portrait of the Artist Losing His Marbles,* Arneson now achieved robust likenesses of striking verisimilitude. In part this was the result of a technical advance. Arneson had modeled *Self-Portrait of the Artist Losing His Marbles* from a wheel-thrown clay sphere that was the size of a head. When he began to work almost exclusively with portraiture in the early 1970s, Arneson had to avoid this time-consuming process. He drew on the mold-making training he had received from Edith Heath at Arts and Crafts and developed generic, expressionless self-portraits in four different sizes. Reinforced plaster molds were made for each, so that Arneson need only fill a mold with wet clay one day and begin to work the next. Initially, he used the expressionless self-portraits as a starting point for all his busts, but as he devoted himself increasingly to images of others, he found it necessary to develop a generic head in three sizes.

During this period, Arneson was beginning to mine the history of art before the contemporary period. He is quick to point out that the ceramist's heritage is replete with facial references—among them Etruscan vases, Meissen and early American porcelain, and Gauguin's hand-built "face-cups".[35] He has rejected the formalist emphasis on stylistic innovation, preferring to excavate tradition openly and explicitly. Arneson's awareness of art history is hardly surprising to Roy De Forest, the artist's longtime friend and onetime colleague at Davis. According to De Forest, Arneson's visits to museums are protracted affairs, in which he looks carefully, both "rationalizing" and "personalizing" every sculpture on view.[36] The sculpture collections of the Fine Arts Museums of San Francisco have served Arneson well in this regard. Among the many works on permanent display is a particularly striking terracotta self-portrait by the eighteenth-century sculptor Charles Antoine Coyseveaux (fig. 33).[37] In Arneson's notebooks of that time there is, in fact, a study of a bust portrait that resembles the Coyseveaux work and may have been a source for Arneson's self-portraits (fig. 34).

Of the eighteen self-portraits Arneson completed in 1971-72, *Classical Exposure* (fig. 36) and *Fragment of Western Civilization* (pl. V) are particularly noteworthy, ranking with the artist's finest works and establishing his paradoxical relationship with tradition. In the former work, the artist appears as a cigar-smoking, classical herm, with both genitals and feet protruding from the column. While the pedestal provided a historical reference, it also served an important formal function, allowing Arneson to establish the scale of his sculpture independent of the exhibition bases on which galleries and museums mounted his works.

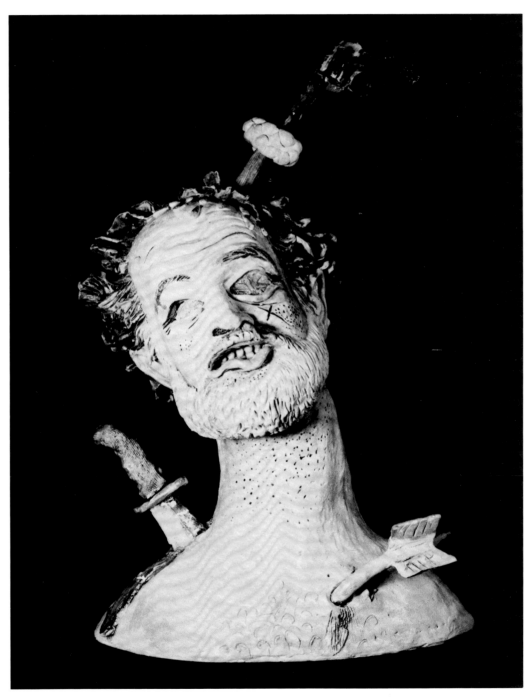

Fig. 35. *Assasination of a Famous Nut Artist,* 1972 [cat. no. 17].

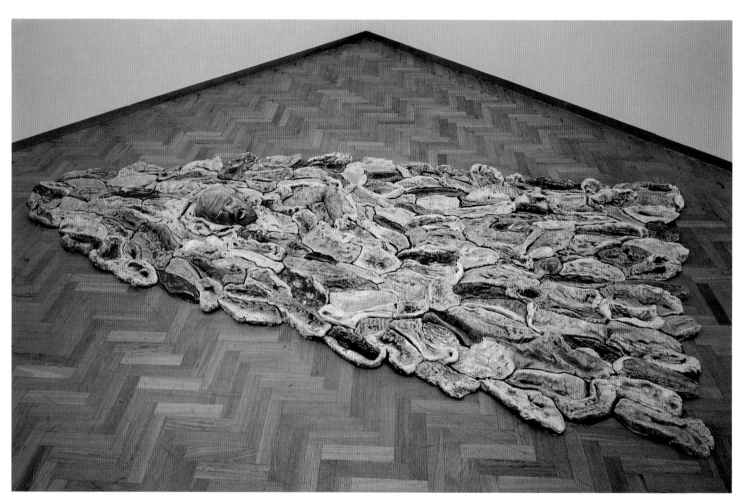

Pl. VI. *Current Event*, 1973 [cat. no. 19].

Pl. VII. *Drawing for Ikarus*, 1980 [cat. no. 55].

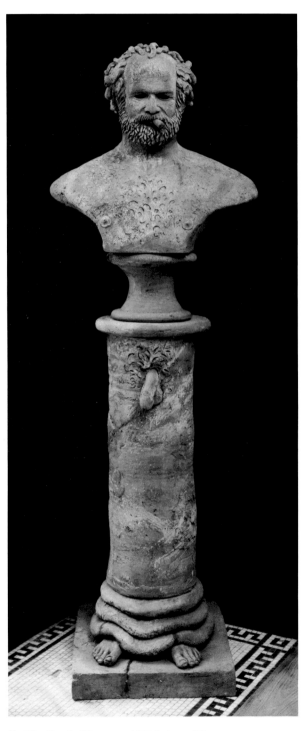

Fig. 36. *Classical Exposure*, 1972 [cat. no. 15].

By contrast, *Fragment of Western Civilization* rests directly on the ground. Although at first glance the work appears to be merely a toppled brick wall, closer inspection reveals a fragmented self-portrait in relief. The use of bricks in this manner is itself interesting since bricks—like ceramic toilets and tiles—are yet another component of the ceramic sculptor's legacy. Figurative brick relief has a rich history, dating to Persian and Khmer sculptors who imbedded figurative compositions in temple and palace walls. Implicit here, is the historical evolution of the ceramist from a mason to a sculptor—the artisan who formerly made bricks and constructed walls now lays claim to status as an artist.

The concept underlying *Fragment of Western Civilization* was rooted in tradition; however, imitating the art of the past was not Arneson's sole intention:

> I had been doing series of bricks for years and there was a concept there of building an edifice that would be of laminated bricks in my likeness. When I got halfway through *Fragment*, I decided that I ought to bring in the hoards of conquerors to dispose of the edifice. There's the yin and yang in that—you build an edifice and then you knock it down.[38]

The act of making a sculpture and then toppling it in order to radically alter its form and meaning is emblematic of Arneson's attitude toward tradition. Although his iconoclasm owes, in part, to the Funk attitudes already described, perhaps more important is Arneson's determination to overcome his burdensome heritage as a ceramist. Drawing on the tradition of figurative relief sculpture in brick in this work and in *Kiln Man*, 1971 (fig. 37), Arneson achieved a new format for self-portraiture while eschewing his roots as a mason and a potter.

Although Arneson's formal achievement reached an unexcelled peak during the 1970s, subtle changes differentiate the work of the early 1970s from later pieces. *Current Event*, 1973, (pl. VI) is possibly the most technically accomplished work of Arneson's career, comprising 177 component parts placed on the floor in the configuration of a triangular wave. Arneson swims against this glossy blue-green wave, his dry, unglazed terracotta skin in marked contrast to his aqueous surroundings. The artist obviously enjoyed the allusive contrast between wet and dry as well as his ability to suggest movement within the clay. If *Current Event* represents the artist swimming confidently against the stilled tide of ceramic tradition, *Balancing Act*, 1974 (fig. 39) indicates the difficult and precarious nature of his effort; and a later pedestal sculpture *Last Gasp*, 1980 (fig. 40), presents an unmistakably pessimistic view. In *Last Gasp* the contrast of movement and stasis is again apparent—the artist surfaces from beneath the water, soaking the dry column—but Arneson now gasps for air. In *Drawing for Ikarus* (pl. VII) also done in 1980, Arneson assumes the guise of the mythical and ill-fated aviator after the fall, swimming valiantly but ultimately hopelessly.

Similarly disturbing are a number of self-portrait-as-clown images, beginning in 1978. In two such sculptures *Klown* (pl. VIII) and *Balderdash-Dash* (fig. 42), the artist's tongue emerges grotesquely from a tightly fitting mask scarcely concealing the man beneath.

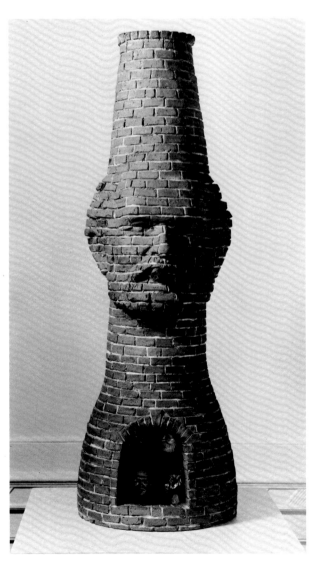

Fig. 37. *Kiln Man*, 1971, [cat. no. 13].

Fig. 38. *Blown*, 1973 [cat. no. 18].

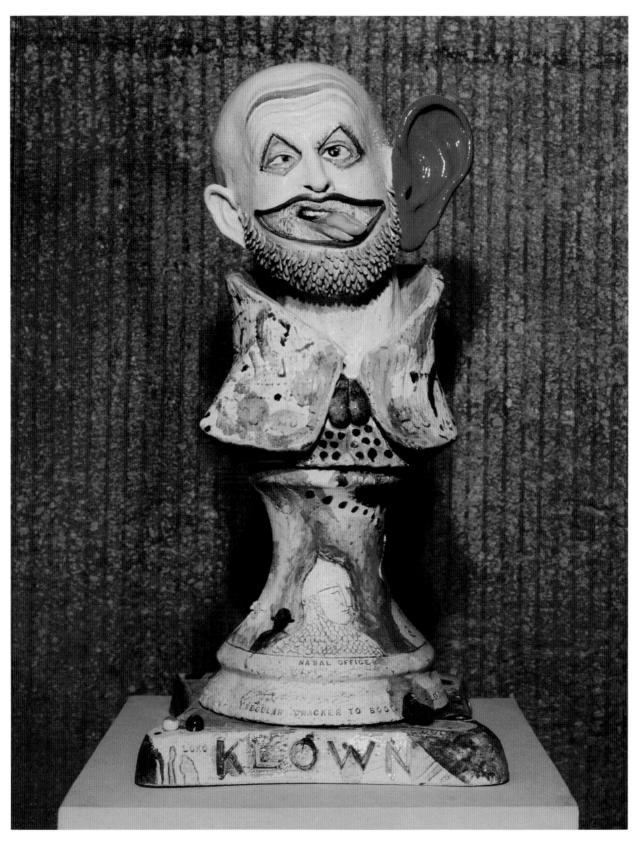

Pl. VIII. *Klown*, 1978 [cat. no. 24].

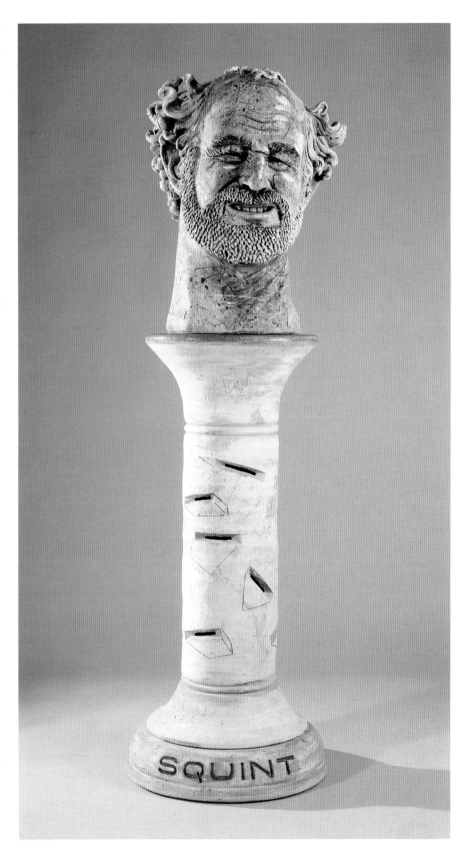

Pl. IX. *Squint*, 1980 [cat. no. 31].

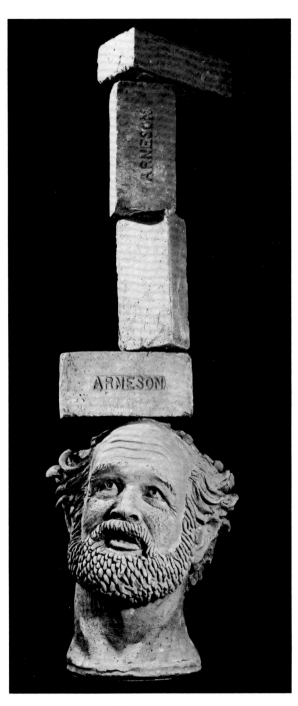

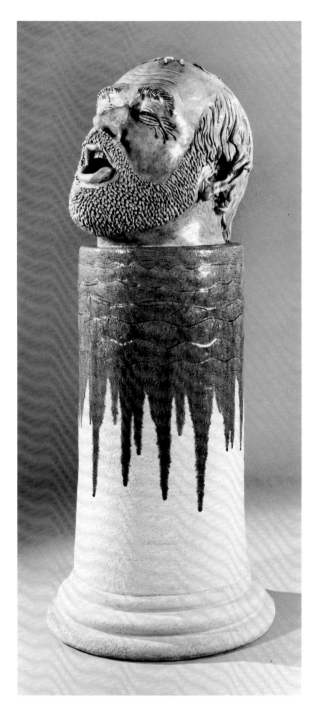

Fig. 39. *Balancing Act*, 1974, [cat. no. 21].

Fig. 40. *Last Gasp*, 1980, glazed ceramic, 52 x 26½ x 17".
Collection of Richard Brown Baker.

Fig. 41. *Clown*, 1978 [cat. no. 51].

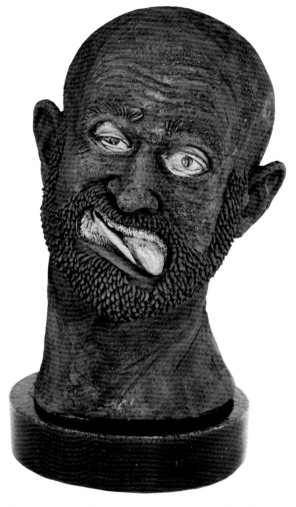

Fig. 42. *Balderdash-Dash*, 1978, glazed ceramic , 33½ x 20 x 20". Collection of Martin Sklar.

Klown bears an enormous red/orange ear and *Balderdash-Dash* seems a victim of immolation, a ghostly forerunner of Arneson's later work on the subject of nuclear war. Numerous mask images also appear at this time, among them *Double Mask: Wearing a Happy Face*, 1978 (fig. 43), in which the artist replaces his grimacing caricatured face with an image of agony in the form of a death mask. Equally grotesque is *Mr. Hyde*, 1981 (fig. 44) in which Arneson attacks his own likeness with violent color, imbedding marbles in the face to exaggerate the horrific effect.

Events of the 1970s illustrate the ironic interaction of Arneson's life and art. Early in the decade he had remarried and developed a new body of work centering on portraiture. He had also established a new and successful arrangement with Allan Frumkin in 1975; and following his 1977 exhibition with the Frumkin Gallery, *New York Times* critic Hilton Kramer described his work as ''unashamedly amusing and brilliant,'' demonstrating a ''stunning mastery of characterization.''[39] In stark contrast to these successes, Arneson de-

veloped cancer during these years and has subsequently undergone repeated treatments and operations.

A vigorous and spirited man, Arneson minimizes any direct connection between his illness and the changes in his work after 1975. Instead, Arneson describes a renewed sense of purpose and a more serious lifestyle and working manner evolving from the experience. Formerly a member of the Bay Area's rambunctious and fun-loving community of artists, since his illness, Arneson has lived somewhat more privately, sharing a large two-story Benicia studio with Sandra Shannonhouse and distancing himself from both colleagues and students.

Through the difficult period in the 1970s, Arneson continued to make self-portraits, but as the decade progressed, he also turned his attention to portraits of artists, many of whom are close personal friends. While these works cover a wide range of individuals and differ radically in their characterization, a development away from good-natured humor and toward more potent expression is discern-

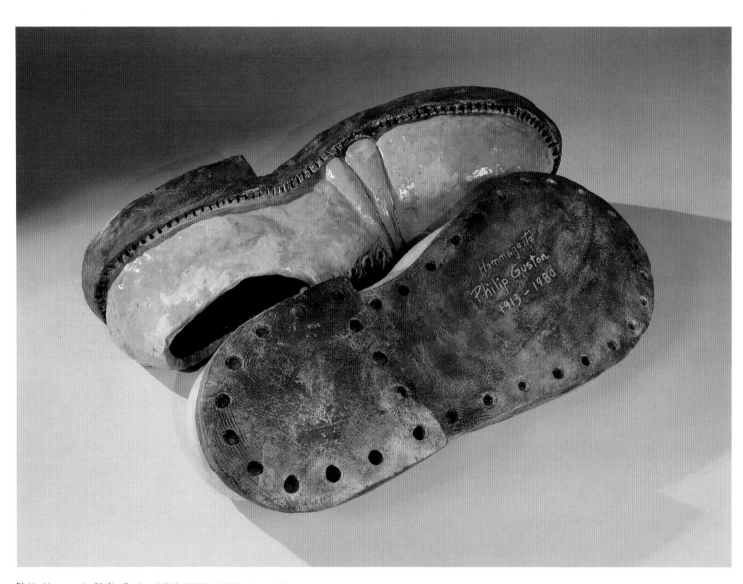

Pl. X. *Homage to Philip Guston (1913-1980),* 1980 [cat. no. 32].

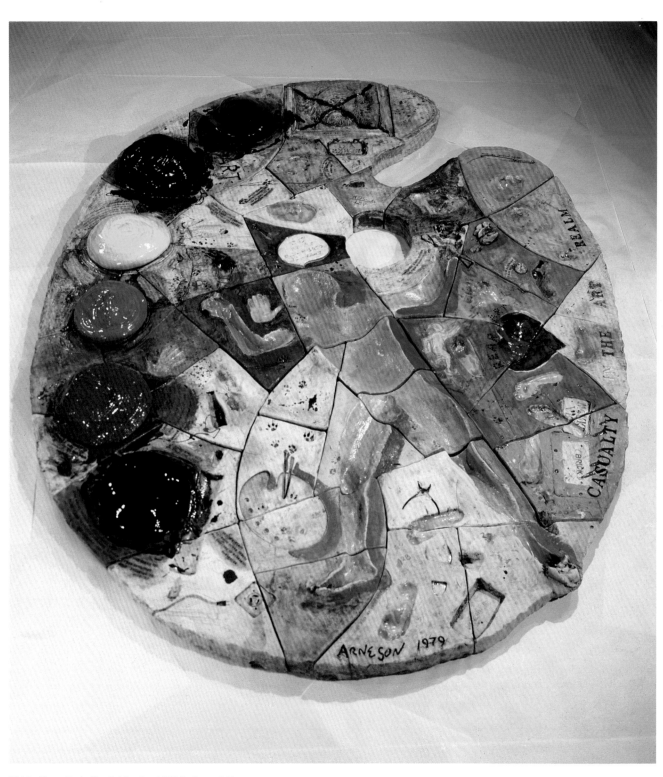

Pl. XI. *Casualty in the Art Realm,* 1979 [cat. no. 29].

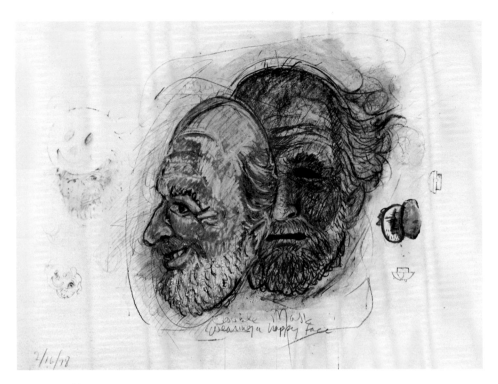

Fig. 43. *Double Mask: Wearing a Happy Face*, 1978, conte crayon and collage on paper, 31 x 40". Collection of Robert Arneson and Sandra Shannonhouse.

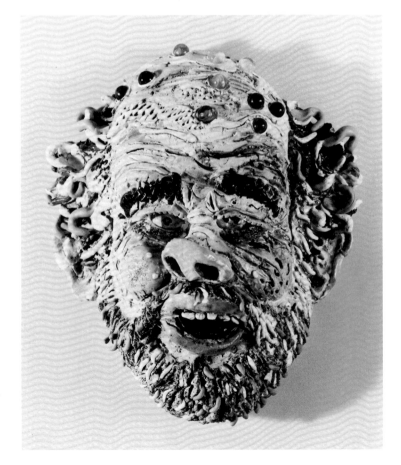

Fig. 44. *Mr. Hyde*, 1981 [cat. no. 33].

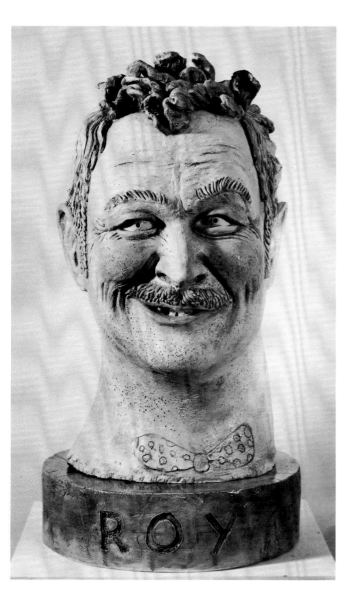

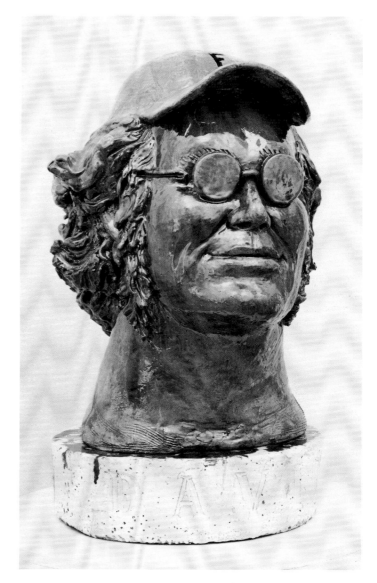

Fig. 45. *Roy of Port Costa*, 1976 [cat. no. 23].

Fig. 46. *David*, 1977, glazed ceramic, 35 x 22 x 21". Philadelphia Museum of Art, Baugh-Barber Fund.

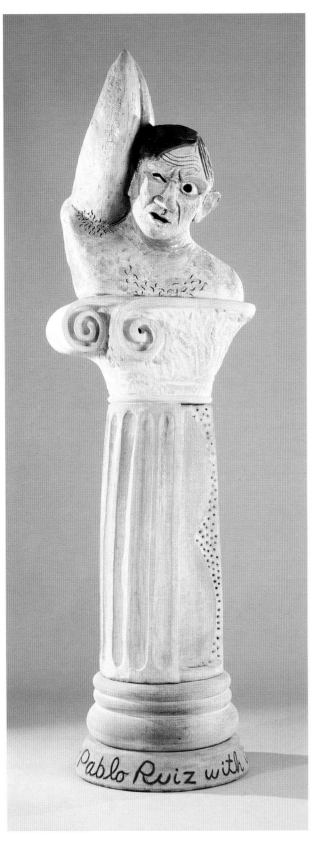

Pl. XII. *Pablo Ruiz with Itch,* 1980 [cat. no. 30].

able both in Arneson's choice of subjects and their realization in clay. The earliest of these works is Arneson's portrait of Roy De Forest, titled *Roy of Port Costa,* 1976 (fig. 45). A bust portrait above a short, disk shaped pedestal, it is an affectionate work, capturing De Forest's wide-eyed, quizzical expression and chronically tousled hair.[40] Completed the following year was *David* (fig. 46), an equally sympathetic likeness of David Gilhooly, in which the green that appears throughout his protégé's sculpted fantasies on the subject of frogs is applied to the face of the sculpture. Also in this vein is Arneson's *Mr. Unatural,* a bust of William Wiley (figs. 47 and 48). Here, for the first time, Arneson incorporated specific iconographic elements in a portrait, a device that owes to Wiley himself, who is depicted wearing the dunce cap and clown nose of his well-known alter ego, Mr. Unatural.

Between 1978 and 1981, Arneson addressed himself to iconic figures in the history of modern art, resuming his dialogue with tradition with the same seriousness of purpose that is reflected in the self-portraits of these years. Rather than creating highly personalized accounts, as in the De Forest, Gilhooly, and Wiley portraits, Arneson relied heavily on historical likenesses derived from photographs. Working from secondary sources, drawing became important for Arneson, both in depicting such artists as Duchamp, Bacon, and Picasso and in preparing studies for the sculptures. The preparatory study and subsequent sculpture of *Rrose Selavy,* 1978 (figs. 51 and 52), derive directly from Man Ray's famous photograph of Duchamp, who, like Wiley, is clothed in the guise of an alter ego. A type of historical document of Duchamp, the sculpture refers in word and schematic images to several of the artist's most significant works, among them *Bicycle Wheel, Nude Descending the Staircase,* and *Tu m'.* Indeed, the bust is cast in a soft pink glaze befitting the artist's pseudonym (*eros c'est la vie*).

While *Rrose Selavy* is deferential to Duchamp and his art, Arneson's large pedestal bust devoted to Picasso, *Pablo Ruiz with Itch,* 1980 (pl. XII), combines homage and satire. Its remarkable preparatory study illustrates the extent of Arneson's research into Picasso's art (fig. 53). Included in it are two copies after the Spaniard's early self-portraits, one in a youthful, realist style and the other in a proto-Cubist manner dating to 1907. Arneson used the latter head in the sculpture and placed it above a large Cubist pedestal, the studies for which appear in the drawing. The head is Picasso's own, but the pose derives from *Les Demoiselles d'Avignon,* 1907 (fig. 54), Picasso's most important Cubist painting. By placing Picasso in the precise pose of one of his celebrated images of prostitutes, and then extending it to show the artist scratching his back, Arneson brilliantly comments on his subject's well-documented business acumen. In developing the sculpture, Arneson made photographs of himself scratching his own back, and by including one such image in the preparatory study, he associated himself both visually and conceptually with the artist.

In 1980-81, Arneson acknowledged the example of two great expressionist painters: Philip Guston and Francis Bacon. In his *Homage to Philip Guston (1913-1980),* 1980 (fig. 55; pl. X), Arneson paid tribute to the painter's late work by making an enormous pair of

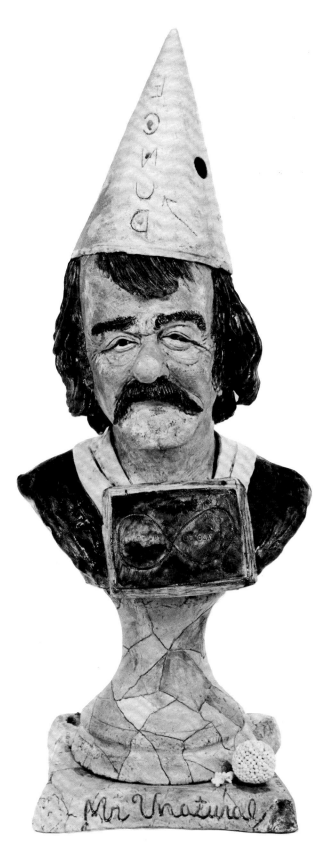

Fig. 47. *Mr. Unatural*, 1978 [cat. no. 26].

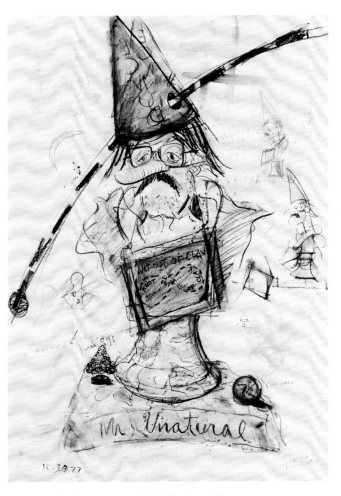

Fig. 48. *Study for Mr. Unatural*, 1977 [cat. no. 49].

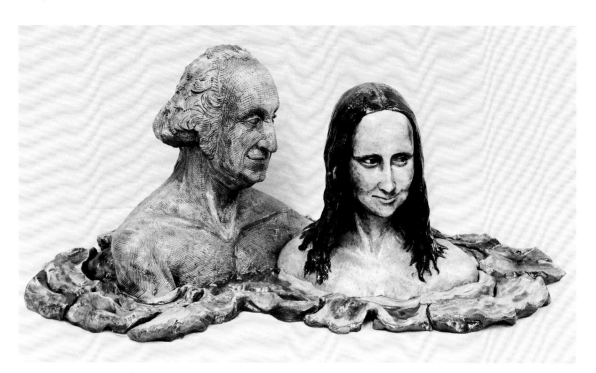

Fig. 49. *George and Mona in the Baths of Coloma*, 1976 [cat. no. 22].

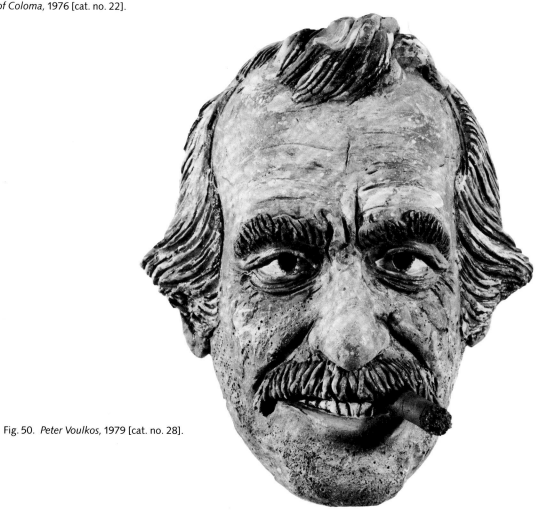

Fig. 50. *Peter Voulkos*, 1979 [cat. no. 28].

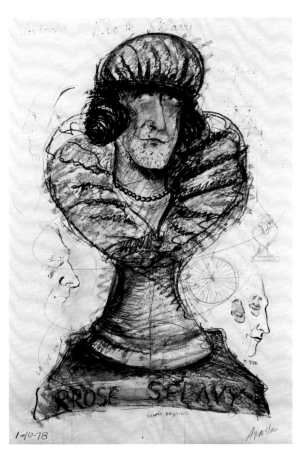

Fig. 51. *Rrose Selavy*, 1978 [cat. no. 52].

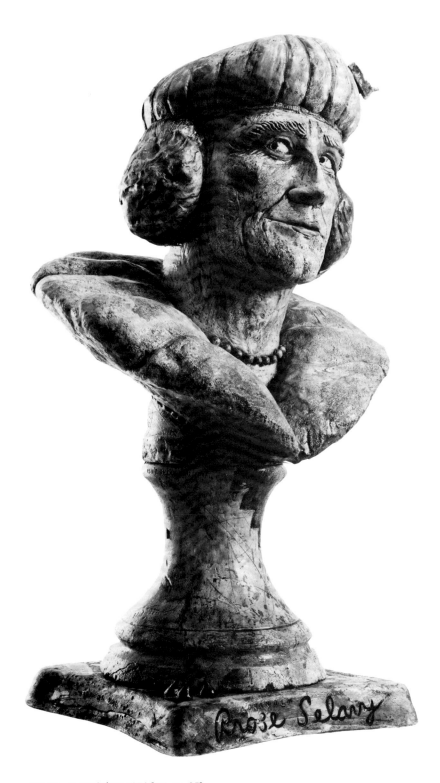

Fig. 52. *Rrose Selavy*, 1978 [cat. no. 25].

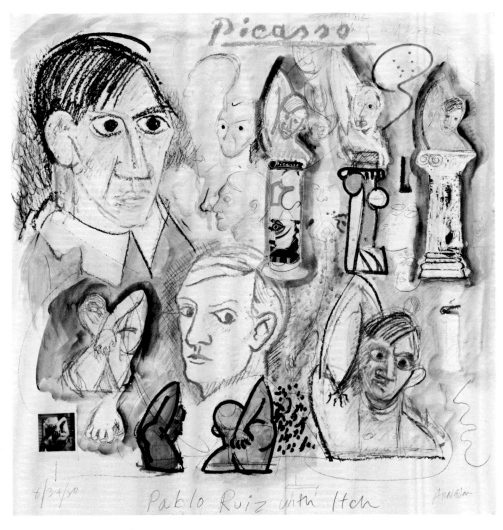

Fig. 53. *Pablo Ruiz with Itch*, 1980 [cat. no. 56].

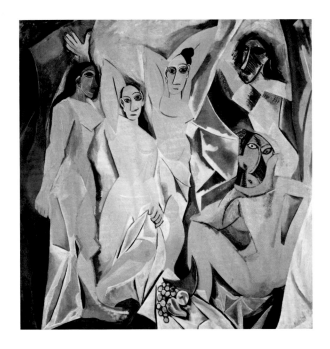

Fig. 54. Pablo Picasso, *Les Demoiselles d'Avignon*, 1907, oil on canvas, 8' x 7'8". The Museum of Modern Art. Lillie P. Bliss Bequest.

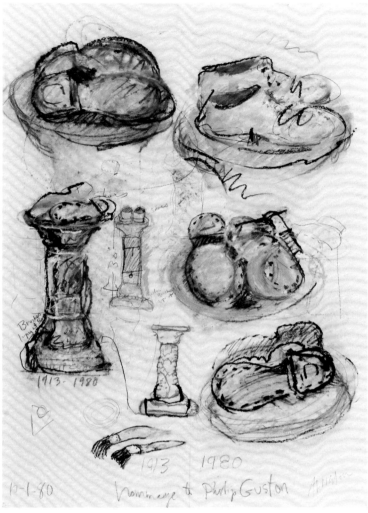

Fig. 55. *Homage to Philip Guston,* 1980 [cat. no. 53].

shoes, an emblem central to Guston's final achievement. Arneson executed a number of portraits of Bacon in various forms—masks and drawings as well as a large sculpture (figs. 56 and 57). In the latter, Arneson applied the grotesque imagery of Bacon's painting to the English artist's likeness, combining a number of contorted views of Bacon ranging from a twisted frontal image to a darkened, shadowy profile. Such contortions were particularly appropriate to the mask format and Arneson's *Raw Bacon* has pink skin, a blood red mouth, and hollowed eyes (fig. 58). Despite the toughness of these images, Arneson intended no disrespect for Bacon. In fact, the British painter's expressionism has often been a model for Arneson's own; the *Portraits of the Artist After Bacon,* a series of masks dating to 1981, are homages to the transforming power of Bacon's painting.

The tradition of caricature within which Arneson works is centuries old.[41] Apparently first practiced by the Italian Baroque painter Annibale Carracci near the beginning of the seventeenth century, caricature or *caricare* (literally to load, in Italian) has generally been a vehicle for the mockery of well-known public figures, exaggerating recognizable anatomical forms while retaining the essence of the subject's likeness. Caricature is thus a highly public art, which depends for its impact on our ability to identify the individual portrayed and understand the nature of the artist's assault.

Having begun as a cartoonist, Arneson is especially conversant with this tradition and he has expanded it with his large scale, biographical bust portraits. Prior to Arneson, only two sculptors worked successfully in this vein: F.X. Messerschmidt, whose eighteenth-century self-portraits with exaggerated facial gestures (fig. 32) served as a model for Arneson's own; and Daumier, who made some thirty small bronzes in the 1830s satirizing the deputies of Louis-Phillipe.[42] In contrast to Daumier's virulent political broadsides, Arneson's caricatures combine impudence and reverence as his subjects Picasso, Bacon, Duchamp, and Guston are all personal heroes.

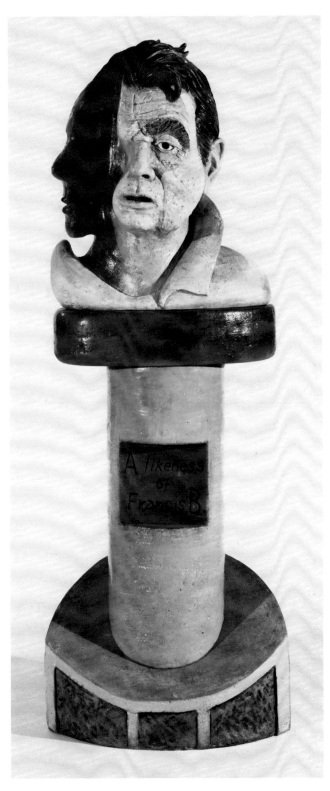

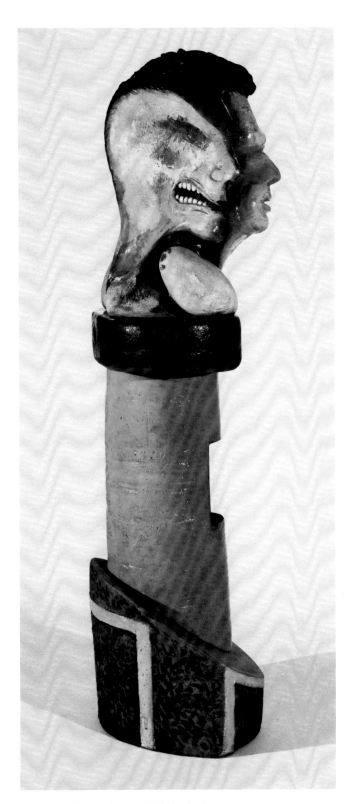

Fig. 56. *A Likeness of Francis B.*, 1981, glazed ceramic, 75 x 30½ x 19½" (front view). Collection of Sydney and Frances Lewis.

Fig. 57. *A Likeness of Francis B.* (side view).

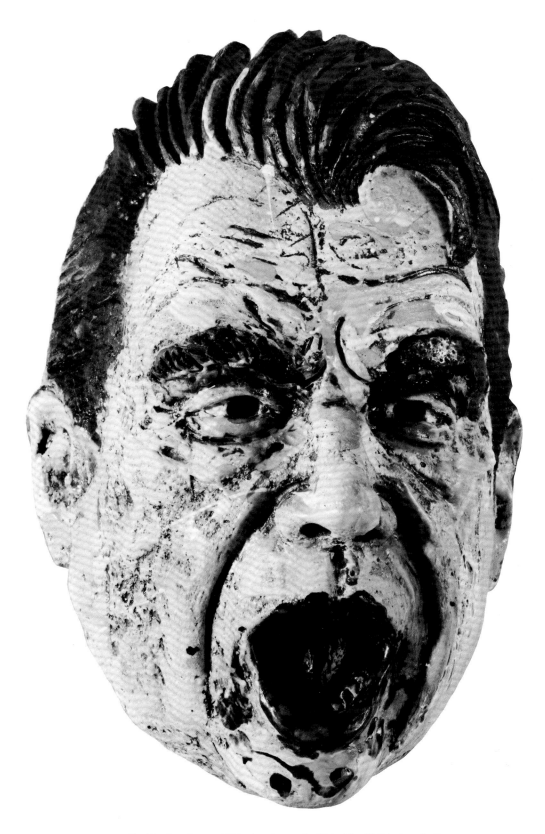

Fig. 58. *Raw Bacon*, 1981, glazed ceramic, 15¼ x 10 x 6″. Private collection.

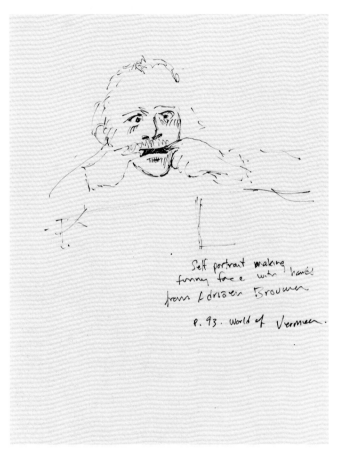

Fig. 59. *Untitled,* (after Brouwer), c. 1972, ink on paper, 11 x 8½". Collection of Robert Arneson and Sandra Shannonhouse.

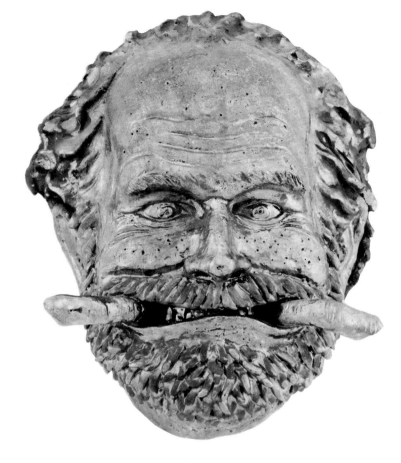

Fig. 60. *Exaggeration,* 1972, glazed ceramic, 14 x 12 x 8". Collection of Mr. and Mrs. E.A. Bergman.

Because Arneson's caricatures have been perceived as simply satirical attacks on modern art's iconic figures, critics have branded them "facetious," and "limited in ambition."[43] Such criticism under-estimates the depth of Arneson's iconoclasm, and completely misses the artist's message. In fact, Arneson's impudence extends far beyond artistic models to an all-encompassing irreverence for an inviolable *status quo*. At times, he challenges artistic convention, as in *Smorgi-Bob, the Cook,* contradicting Renaissance notions of pic-torial illusionism. In his work *Casualty in the Art Realm,* 1979 (pl. XI), he pokes fun at the art world that has elevated Duchamp, Picasso, and Bacon to the status of legends, but dismisses him as simply comic. In *A Question of Measure* (fig. 61), Arneson replaces Leon-ardo's perfectly proportioned, ideal male figure with his own stout likeness, debunking the notion of man as the measure of all things, the most perfect of all beings.

By the end of the decade, this iconoclastic sensibility was most powerfully applied to his own likeness, as emotional, expressive con-cerns superseded punning and intellectual gamesmanship. He was always captivated by self-portraiture with a grotesque element. A notebook copy after Adrian Brouwer's *Self-Portrait with a Funny Face,* which exemplifies his attitude, became the source of his first mask, *Exaggeration,* in 1972 (figs. 59 and 60). It was not until the late 1970s, however, that Arneson imbued his work with ominous and even macabre overtones. This was unquestionably due to the cir-cumstances of his health, which Wiley, in a particularly vivid meta-phor, characterizes as being awakened by an "extra hard knock" on the door every morning.[44] Since 1981, additional circumstances have inveighed against humor in Arneson's art, and his innate doubt has approached a more universal form of iconoclasm.

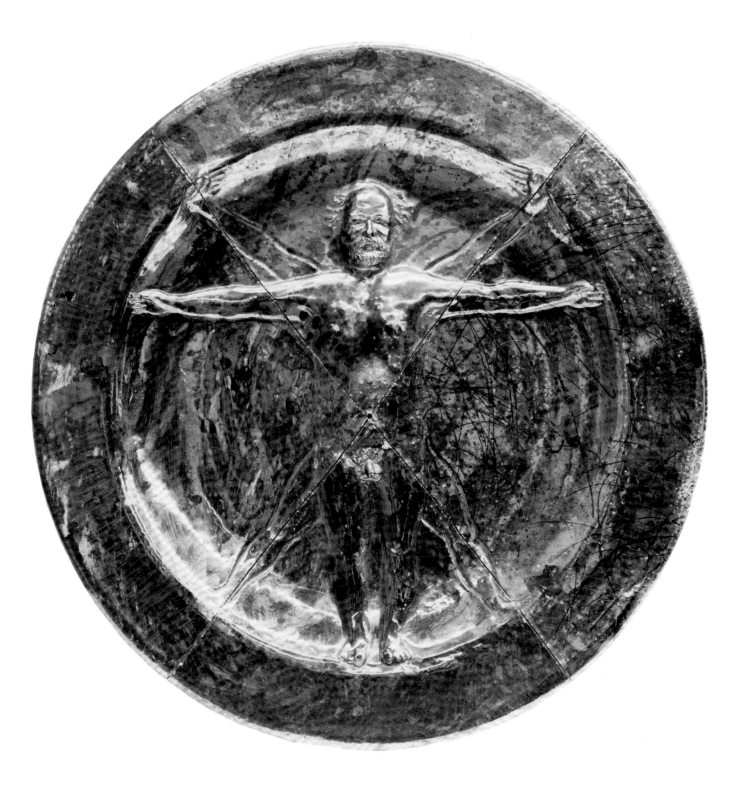

Fig. 61. *A Question of Measure*, 1978, glazed ceramic, 19" (diameter). Collection of Gilda and Henry Buchbinder.

Fig. 62. *Iconoclast,* 1974 [cat. no. 48].

In an act of desperation, former San Francisco supervisor Dan White entered the office of Mayor George Moscone on the morning of November 17, 1978. Following minutes of heated conversation, White took Moscone's life with four shots from his Smith and Wesson revolver. He hurriedly reloaded his gun and proceeded to the office of his former colleague Harvey Milk and shot him five times.[45] The twin killings of these popular civic officials shocked a community only beginning to recover from the mass suicide two weeks earlier of 900 members of the Peoples Temple, a quasi-religious cult based in Guyana, but founded in San Francisco. Even to a city accustomed to heated and extreme political dialogue and occasional violence, the deaths of Moscone and Milk were unparalleled civic blows.

While the days and weeks following the murder brought only silent despair for San Franciscans, six months later, in May 1979, the city's mood turned violent. Dan White, unable to plead guilty by reason of insanity—because no psychiatrist would support such a

plea—concocted with his attorneys a defense based on his penchant for junk food, which subsequently came to be known as the "Twinkie Defense." When he was found guilty of voluntary manslaughter rather than the first degree murder charge that had been sought, San Franciscans were outraged.[46] The city's Gay community, fiercely loyal to Milk, took to the streets. The "White Night" riot at city hall left 119 people injured (59 of them policemen), twelve burned police cars, and one million dollars in damage. Even Moscone's successor, Diane Feinstein, who had discovered Milk's body and who was equally outraged by the verdict, could not calm the rioters when they briefly invaded city hall. Although the passions unleashed that evening were eventually calmed, they remained scarcely concealed.[47] It would be Robert Arneson's misfortune to rekindle them in 1981 through the power and directness of his art.

Soon after Moscone's assassination the city of San Francisco decided to name a long-planned convention center after the dead

Fig. 63. *Captain Ace*, 1978 [cat. no. 27].

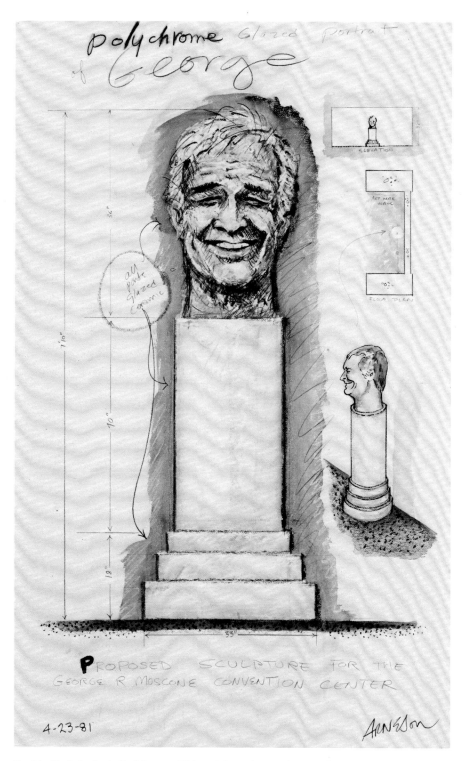

Fig. 64. *Study for Portrait of George,* 1981, pastel, graphite, and watercolor on paper, 44⅞″ x 28″.
Collection of the San Francisco Arts Commission.

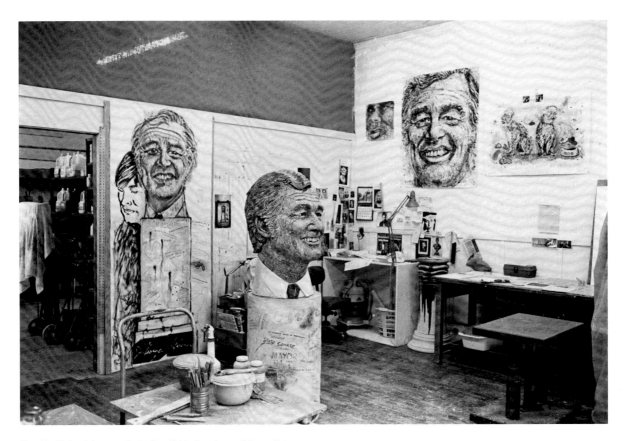

Fig. 65. Robert Arneson's studio, 1981. Courtesy of the artist.

mayor. As the complex neared completion early in 1981 it was decided that approximately $550,000 would be allocated for works of art to decorate the building, and Arneson was one of thirty artists asked to submit a proposal. The wording of the invitation to particiapte in the limited competition would later prove crucial: "We request that you prepare a sketch (maquette or model if appropriate) sufficiently detailed so that a judgment can be made. . . ."[48] Arneson responded with a sketch for *Portrait of George* (fig. 64), which was delivered to the San Francisco Art Commission, the administrators of the project. The study, for which he was paid $2,500 and which remains in the possession of the city, represents an early conception of the work. Arneson had sketched the bust as a realistic likeness tending toward mask-like caricature. The smile was naturalistic yet slightly inane, a demonstrably accurate rendering of Moscone that was simultaneously a caricature of a politician. Although in previous full-length pedestal busts, like *Pablo Ruiz with Itch,* Arneson conceived both bust and pedestal as a single entity, the Moscone pedestal remained blank at this preliminary stage.

From the twenty-two artists who submitted proposals, Arneson was selected along with Paul Wonner, Tom Holland, Katherine Porter, Gustavo Rivera, and Sam Gilliam. His contract with the city specified a fee of $37,000, half payable at its signing and the other half on the

acceptance of the work by the Art Commission. By July, Arneson was under contract and at work on the piece. He developed larger, more finished drawings (pl. XIII) and began work on the clay head:

> I began to think of information I could put on the pedestal to liven it up with color and graphics. I went through *Time* and *Newsweek,* newspapers, got data to see what kind of words and images I could incorporate. I asked Gina Moscone to give me a list of things that she remembered that would not be in print. Funny sayings. She mailed me a list and I told her that I would be embellishing the pedestal with scenes from his life, to explain who he was.[49]

The inscriptions Arneson incorporated were biographical in nature, ranging from professional references ("Hastings Law School," "Board of Supervisors," and "State Senate") to some of Moscone's favorite expressions ("Trust me on this one." and "Is everybody having fun?"). While these were innocuous and unobjectionable, other references to the specific events surrounding the assassinations ("Smith and Wesson." "Harvey Milk, too." and "Twinkies.") were ultimately to incite controversy.

The essence of Arneson's bust lies in the artist's unusual conception of portraiture. Just as his portraits of Duchamp, Picasso, and

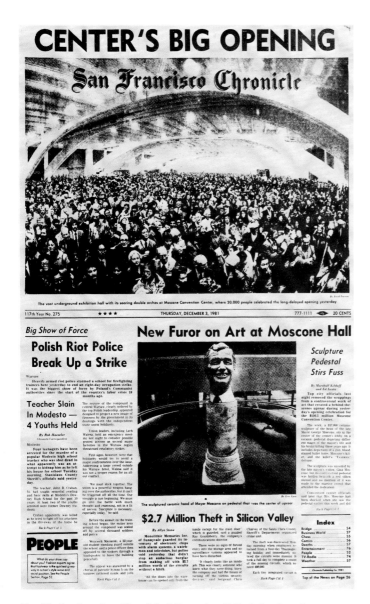

Fig. 66. *San Francisco Chronicle*, 3 December 1981. © *San Francisco Chronicle*, reprinted by permission.

others are not straightforward likenesses, his work on the subject of an assassinated public official is not merely a memorial. By including detailed if schematically rendered information, Arneson "informalizes"[50] the portrait while enriching the work and its subject. The artist's background as a cartoonist working in word and image served him well here; the pedestal was an ideal surface for the incorporation of graphic references and, thus, the work became a fully-developed biographical bust.

As summer became fall, the sculpture neared completion (fig. 65). On one occasion, Gina Moscone visited Arneson's studio to see the work. At that time, the head and many of the inscriptions were complete, but Arneson covered up the references to the assassination, believing it unnecessary "to confront her with all of it."[51] On November 13, the Art Commission was invited to view the recently completed work, but only one member, Richard Mayer, attended. Arneson recalls that Mayer, himself a sculptor, was somewhat concerned about the pedestal and made photographs to distribute to other commission members. Yet, Arneson subsequently gained permission to install the work, and he did so on November 29.

Although the center was closed to the public, rumors concerning Arneson's pedestal abounded in San Francisco prior to the opening on December 2. When Arneson learned from city officials that Gina Moscone would personally unveil the sculpture during the opening ceremony, he called and asked her to not to do so because she would be upset by certain references on the pedestal. Indeed, after viewing the work, Mrs. Moscone was upset and she asked that the pedestal be draped during the opening. In deference to her, Arneson assented, knowing full well this would only feed the growing controversy.

Arneson's fears were justified. On the day of the opening, curiosity about the pedestal outweighed all else, and press and public pressure became so intense that following the festivities Mayor Diane Feinstein led a group of city officials and press photographers back to the center to uncover the work. The sculpture was immediately front page news (fig. 66), with the *San Francisco Examiner* declaring *Portrait of George* "blatantly weird" and calling for its "demolition."[52] Feinstein quickly invited Arneson, Art Commissioners, and city officials to a meeting on December 4 to try to resolve the problem. During this meeting, she suggested that either a new pedestal be designed or a second sculpture be executed, one in bronze and without a pedestal. Arneson immediately ruled out the first alternative and ultimately the second, as well. Feinstein then made public a letter addressed to the Art Commission, which would either accept or reject each of the six works at its December 7 meeting:

> The pedestal in its present form simply is not appropriate as the hallmark of a great center that monthly will attract thousands of persons from throughout the nation and, indeed, the world. On memorials to Lincoln or the Kennedys or Martin Luther King or other fallen leaders it has never been expected or thought necessary to make reference to their killers.[53]

Two days later, on Sunday, December 6, the sculpture was removed from the center and placed in storage at the San Francisco Museum

Fig. 67. George Segal, *In Memory of May 4, 1970: Kent State—Abraham & Isaac*, 1978, plaster, rope, and metal, 84 x 120 x 50″. Courtesy of Sidney Janis Gallery.

of Modern Art. Not surprisingly, the Art Commission, composed of mayoral appointees, rejected the work the following day by a seven to three vote.[54] Although considerable ink was spilled regarding the fate of the commission and the legalities involved, Arneson's role was effectively concluded when he returned his $18,500 advance and regained control of the sculpture. Legalities aside, the history of Arneson's Moscone commission can be seen as a paradigm of the peculiar difficulties that figurative public sculpture has encountered in the twentieth century.

A tenet fundamental to modernism demands that artists devote themselves to ideals and movements, but not to the glorification of individuals and their deeds.[55] For this reason modernist sculptors have generally avoided publicly commissioned memorials and such projects generally have been carried out by "academic" sculptors. With the advent of government and corporate sponsorship of art around 1960, public art has become predominantly abstract because the large scale and simplified form of Pop and Minimalism have proven consistent with the civic and corporate ideals of optimism, ambition, and achievement.

An ironic parallel to the gradual co-optation of the ideals of modernism has been the emergence of progressive figurative art as perhaps the most challenging public art form. With the exception of only the most rigorous and demanding geometric art, direct and meaningful figurative memorials—beginning with Rodin's *Burghers of Calais* and *Monument to Balzac* of the 1890s—often have been

more problematic to the public. The closest contemporary analogue to Arneson's experience is that of George Segal, whose *In Memory of May 4, 1970: Kent State—Abraham and Isaac*, 1978 (fig. 67) memorializes the deaths of Kent State University students protesting the war in Vietnam.[56] Although Segal's memorial treated these events in allegorical, indeed biblical terms, like *Portrait of George*, it was too closely reminiscent of the events in question and was rejected by the University. Although Arneson and Segal approached their respective projects differently—Segal's work is literary in content and moralizing in implication, while Arneson's is a vivid reminder of the events in all-too-graphic detail—each artist had the misfortune to arouse his patron by irritating still raw and ultra-sensitive emotions.

The Moscone commission has an important postscript. Following the sculpture's removal from the Moscone Center on December 6, it was not seen again until the following spring when it was added to the Whitney Museum of American Art exhibition "Ceramic Sculpture: 6 Artists," on view at the San Francisco Museum of Modern Art. Ironically, immediately following his meeting with Feinstein on December 4, Arneson had flown to New York to attend the opening of this exhibition at the Whitney, which included his major works *Current Event* and *The Palace at 9 a.m.* The first important museum survey of the clay sculpture movement, the Whitney exhibition also included Peter Voulkos, John Mason, Ken Price, David Gilhooly, and Richard Shaw. Although the presence of Arneson's work galvanized the show, linking the sturdy expressionism of Voulkos and Mason to

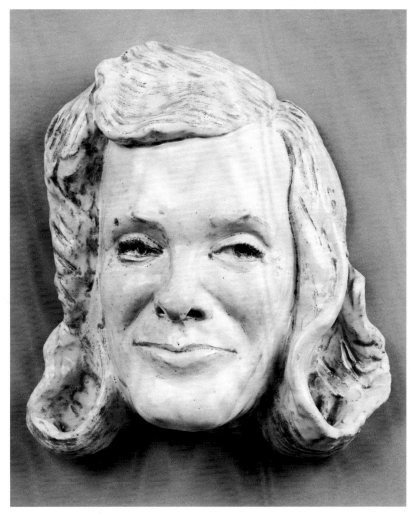

Fig. 68. *China Doll*, 1982, glazed ceramic, 15 x 11 x 6". Collection of Robert Arneson and Sandra Shannonhouse.

Shaw's *trompe l'oeil* objects and Gilhooly's comic creatures, ultimately Arneson's work suffered in the process. Reviewing the exhibition for the *New York Times* on December 20, 1981, thirteen days after the rejection of the Moscone sculpture, Hilton Kramer deplored the "spiritual improverishment" of the cultural life of California and described works such as *The Palace at 9 a.m.* as:

> . . . the mark of a mind too easily pleased with its own jokes. What this attitude amounts to is a kind of moral smugness that we see writ large in the artist's oversized self-portraits, too.[57]

While Kramer acknowledged Arneson's unmatched facility with clay, he also found:

> a gruesome combination of bluster, facetiousness and exhibitionism—placing a fatal limit on what his gifts allow him to accomplish or even to conceive.[58]

The difficulty of creating high art based in humor, yet with a serious purpose, was never more apparent. Indeed, caricature and other forms of humor have long been outside the traditional boundaries of fine art, as the careers of Arneson's predecessors William Hogarth, James Gillray, and Honoré Daumier attest. Even in the twentieth century, the boundaries of artistic taste remain remarkably narrow, with only a thin line separating the trite from the grotesque in the public mind. As Kramer's words reveal, a public deeply respectful of artistic tradition is quick to feel violated when venerable artists and traditions seem maligned, regardless of the form or intent.

However hostile, Kramer's remarks ultimately demonstrated that Arneson no longer need "push his way in,"[59] that is, make art that would outrage and, thus, call attention to the artist. Arneson had achieved a public that might damn or praise his work, but could not ignore it. Yet for the artist, who has always been keenly interested in

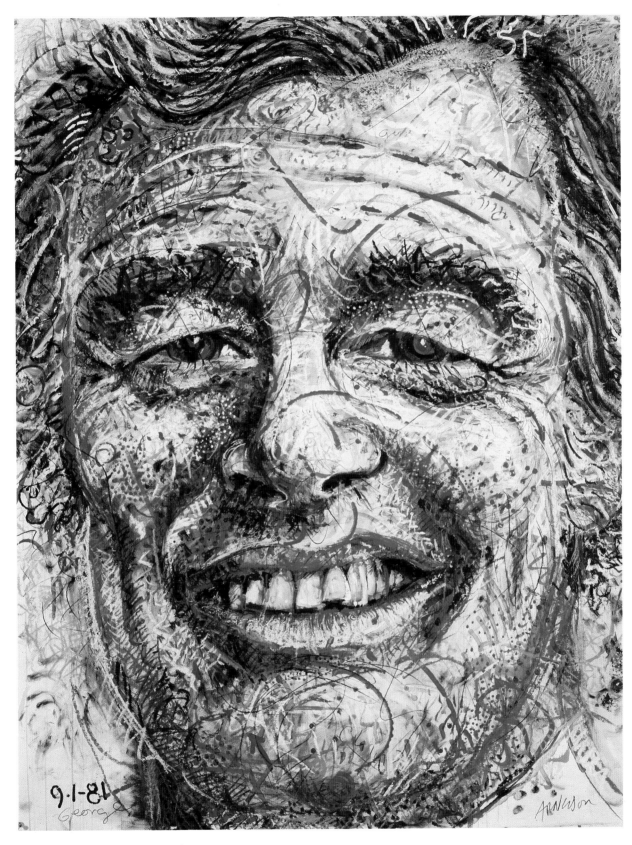

Pl. XIII. *Big George,* 1981 [cat. no. 59].

Fig. 69. *Main Event,* 1982 [cat. no. 61].

Fig. 70. *The Fighter,* 1982 [cat. no. 63].

and sensitive to art criticism, these were the most difficult of times. In the short span of three weeks, his work had been rejected in the most emphatic terms on both coasts. The day after the publication of Kramer's review, the artist analyzed his quandary:

> The things that I'm really interested in as an artist are the things you can't do—and that's really to mix humor and fine art. I'm not being silly about it, I'm serious about the combination. Humor is generally considered low art but I think humor is very serious—it points out the fallacies of our existence. Hilton Kramer called me a defiant provincial, and also mentioned moral

smugness. Obviously, because I deal a lot with self-criticism in self-portraits, I am going to have to think about all of it.[60]

The combination of the Moscone experience and, to a lesser extent, Kramer's criticism, caused Arneson to rethink his attitude toward art and his previous work. Since 1982, he has assumed this criticism as a personal challenge and has defined his art in terms of moral responsibility and political commitment. In so doing, he has eradicated his onetime image as a "wit and a wag,"[61] and reshaped the content of his art and the direction of his career.

Pl. XIV. *Harvey Milk*, 1982 [cat. no. 62].

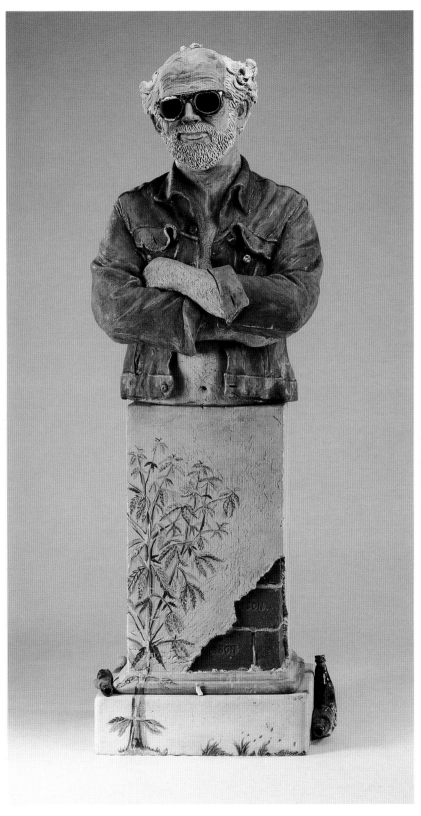

Pl. XV. *California Artist*, 1982 [cat. no. 37].

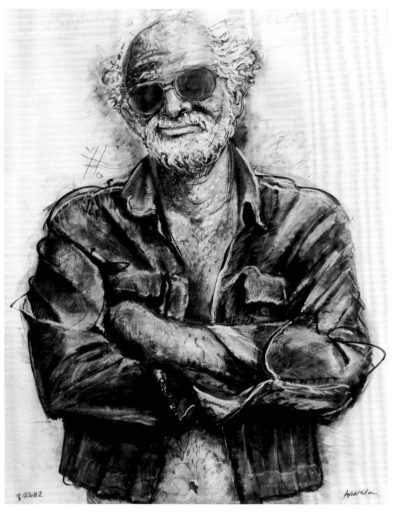

Fig. 71. *California Artist,* 1982 [cat. no. 64].

Although there is a marked change in Arneson and his work after 1981, he did not suddenly lose his sense of humor nor did he abandon wit and ridicule as artistic weapons. That kind of dramatic alteration had to wait until Arneson had vented his anger at the City of San Francisco and Diane Feinstein. Early in 1982, he made a number of drawings of Harvey Milk, frightful, horrific studies of the martyred Gay leader (pl. XIV). Then, again pressing the mask format into service, he presented Feinstein as *China Doll,* 1982 (fig. 68), a porcelain princess drained of all color, emotion, and feeling. Arneson often assumed the guise of a battered, aging boxer, imaging himself "fighting mad"[62] in such drawings as *Main Event* and *The Fighter* (figs. 69 and 70), also of 1982.

His response to Kramer was more complex. While Arneson was hurt by the critic's references to his own work, his comments on the state of "high art in the California sun" and "provincialism"[63] smacked of New York chauvinism and Arneson felt obliged to reply. The artist has long been a stout defender of West Coast art, believing a greater degree of freedom possible at a distance from the narrow strictures of the New York art world. In rhetorically answering Kramer's criticism, Arneson applied each of the critic's stereotypes to his own likeness in *California Artist,* 1982 (fig. 71; pl. XV). The personification of West Coast defiance, Arneson clothes himself only in denim jacket and smug expression, surmounting a pedestal littered with beer bottles, cigarette butts, and marijuana plants. If the eyes are a window to the soul, then Kramer's California artist is indeed a vacuous being; through Arneson's sunglasses there is only a vast and hollow clay head.

Despite its formal and rhetorical brilliance, *California Artist* is one of relatively few self-portraits of the post-Moscone years. Two other major self-images date to 1982: *Self-Portrait with Bio-Base* (fig. 75) and *Ass to Ash* (pl. XVII). Fostered by the circumstances of his health, the Moscone incident, and Kramer's criticism, Arneson's new, more serious attitude first appears in these works. In *Self-Portrait with Bio-Base,* Arneson places a bronze head above a ceramic pedestal replete with biographical inscriptions in the manner of the Moscone sculpture. In *Ass to Ash,* Arneson reflects more expansively

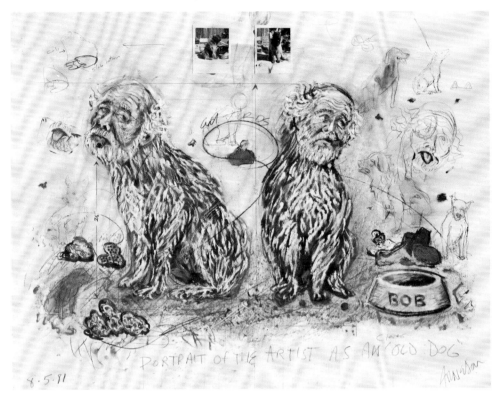

Fig. 72. *Portrait of the Artist as a Clever Old Dog*, 1981 [cat. no. 58].

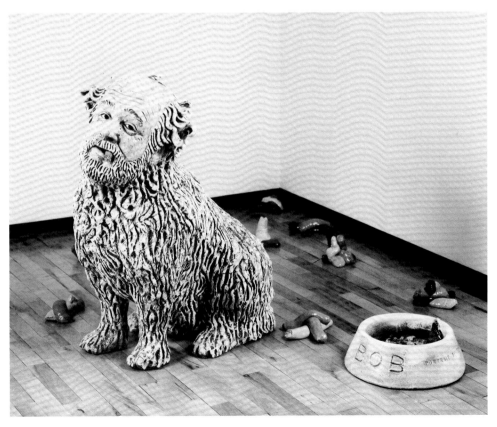

Fig. 73. *Portrait of the Artist as a Clever Old Dog*, 1981 [cat. no. 34].

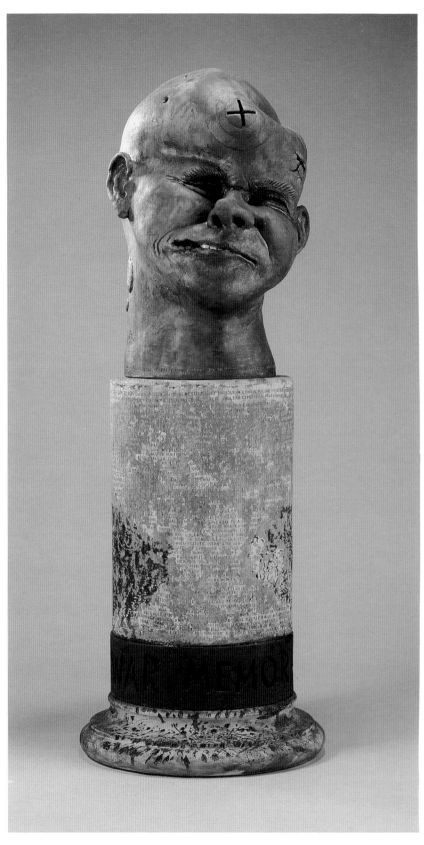

Pl. XVI. *Holy War Head,* 1982-83 [cat. no. 39].

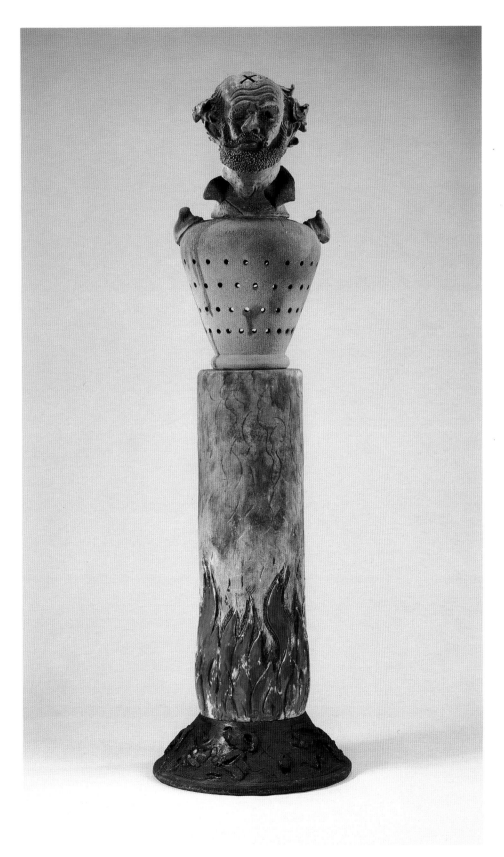

Pl. XVII. *Ass to Ash,* 1982 [cat. no. 36].

on his own illness, placing his sculpted head above a funerary vase that rests on a flaming column. The concept derives from the Etruscans, who set the image of the deceased above funerary amphorae (fig. 74); but in Arneson's hands, it becomes an expressive vehicle, as he twists the head almost beyond recognition.[64] Stamping the title "Ass to Ash" into the shoulder of the vase and incorporating references to violent and fiery death on the column, Arneson universalizes both his illness and his recent struggles as an artist. By any measure, *Ass to Ash* is among Arneson's most personally meaningful and historically important works, culminating such increasingly fatalistic self-images of the late 1970s as *Last Gasp* and *Drawing for Ikarus,* while introducing the theme of nuclear warfare, the subject that obsesses the artist today.

Interestingly, self-portraiture has played a minor role in Arneson's images of nuclear catastrophe. He has worked most often with generalized heads, which, by virtue of their anonymity, have the potential for universal power. Unquestionably the most important of this initial group of "war heads" is *Holy War Head,* 1982-83 (pl. XVI). Here Arneson places a larger than life-size head directly on the pedestal, thereby giving the work human scale and forcing the viewer to confront it directly. In executing the sculpture, Arneson manipulated his largest generic head, lining the interior with moistened plastic and then stuffing it with foam scraps.[65] He then wrapped the outside with wet plastic and, with three blows from a baseball bat, dented one side. Arneson's unorthodox methods proved problematic for the firing process, and the first two heads were irretrievably lost in the kiln. Only on the third try did he succeed, with the battered likeness resembling that of a child and giving the face a powerful and empathetic quality.

Once the head was complete, Arneson turned to the pedestal, carefully incising a long and continuous text into the shaft. The words, which unemotionally yet graphically describe the impact of nuclear fallout in human terms, are quoted from John Hersey's *Hiroshima* and from documentary fact sheets that Arneson acquired through his own research. The artist experienced difficulty in firing the pedestal and the white underglaze flaked away certain segments of the text. Rather than abandon the pedestal, Arneson capitalized on his technical misfortune for expressive effect, allowing these parts of the text to be lost. In the finished work, the column appears to be yet another victim of nuclear catastrophe. The tendency is to alternately read the text and examine the bust as one walks around the sculpture, creating a remarkable synthesis of word and sculptural form perhaps unparalleled in contemporary art. The meaning of the piece is made abundantly clear by the words "A War Memorial," which appear at the foot of the pedestal, just above a blood-spattered base. The naiveté and wrenching malformations of the child's head, combined with the text, serve as a memorial to a catastrophe yet to occur, and constitute an eloquent protest against nuclear warfare.

The point of juncture between head and base has long been a critical formal issue in Arneson's portrait busts. In separating the bust from the base, the artist has at times elongated the neck, as in *Portrait of George,* or used such objects as funerary amphorae, as in

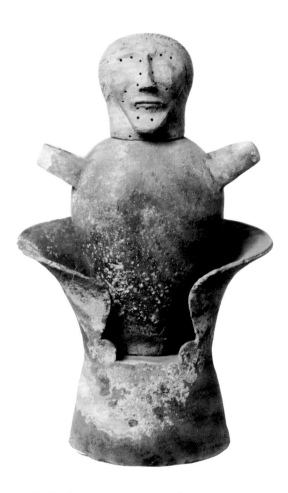

Fig. 74. Etruscan Funerary Urn, 6th century B.C., ceramic, 22¹⁵⁄₁₆″ h. Courtesy of the Trustees of the British Museum.

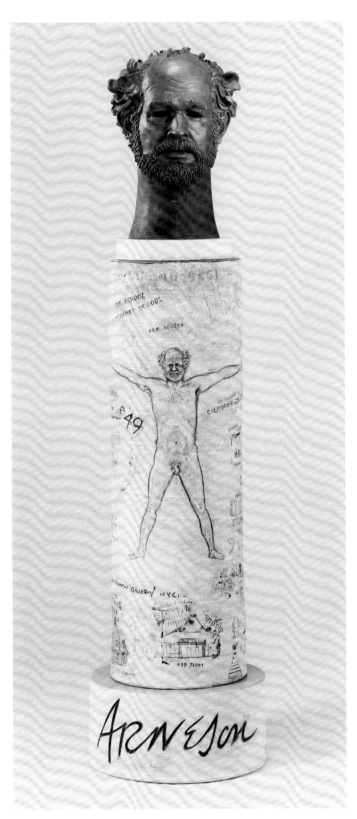

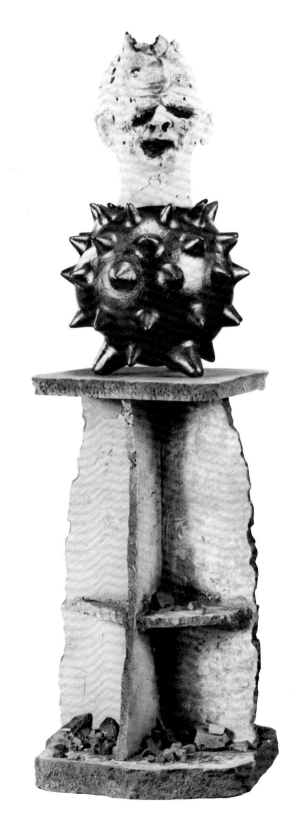

Fig. 75. *Self-Portrait with Bio-Base*, 1982 [cat. no. 35].

Fig. 76. *Head Mined*, 1982-83 [cat. no. 38].

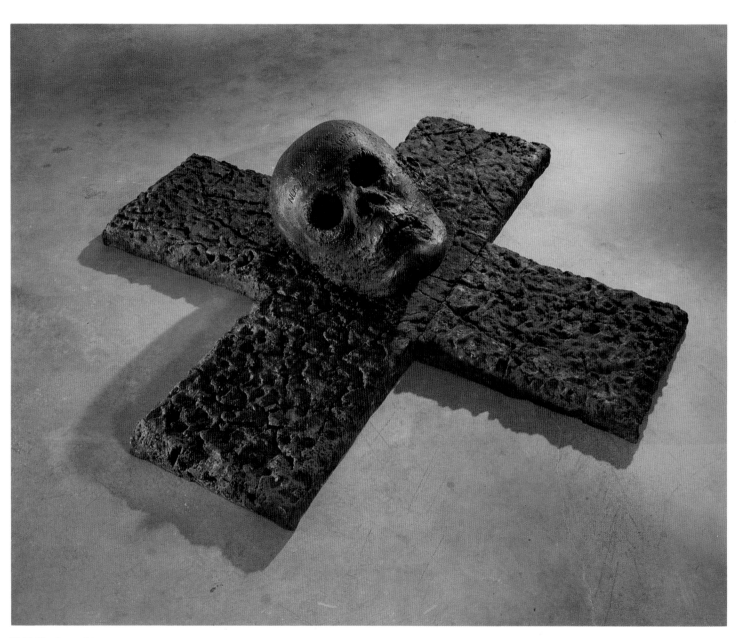

Pl. XVIII. *Ground Zero*, 1983 [cat. no. 40].

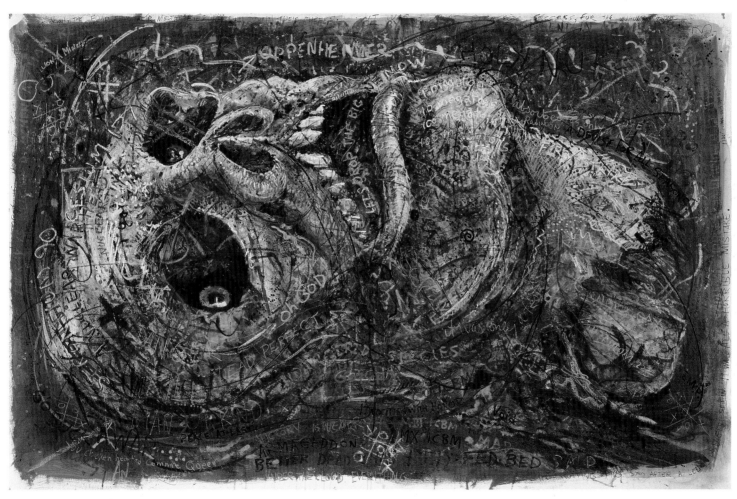

Pl. XIX. *Gotcha*, 1983 [cat. no. 65].

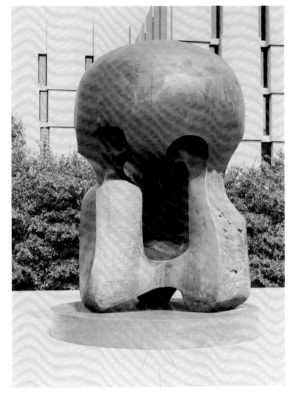

Fig. 77. Pablo Picasso, *Death Head,* 1943, bronze and copper, 9⅞ x 8¼ x 12¼". Musée Picasso, Paris. © V.A.G.A., New York.

Fig. 78. Henry Moore, *Nuclear Energy,* 1967, bronze, 12′ h. The University of Chicago.

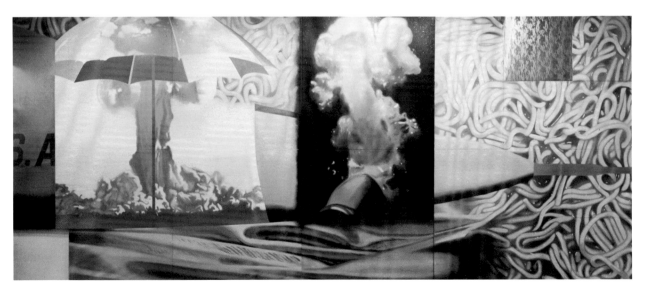

Fig. 79. James Rosenquist, *F-111* (detail), 1965, oil on canvas with aluminum, 10 x 86′. Courtesy of Leo Castelli Gallery.

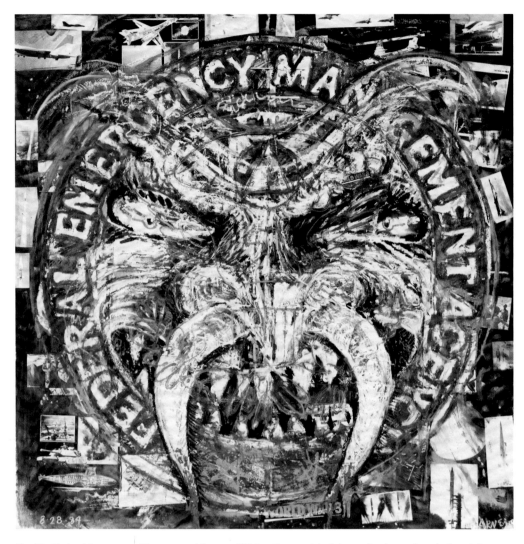

Fig. 80. *Federal Emergency Management Agency*, 1984, collage, paint stick, acrylic, charcoal, and oil pastel,
52½ x 52½". The Art Institute of Chicago, Mr. and Mrs. Alan Press, restricted gift in memory of Harold Joachim.

Ass to Ash. In *Ground Zero,* 1984 (pl. XVIII), he resolved the problem to striking expressive effect by disembodying the head completely and placing it on a cross-shaped floor base, vividly enhancing its expressive power and the theme of total nuclear catastrophe. The work is based on Picasso's *Death Head,* 1943 (fig. 77), which Arneson saw in the "Picasso Sculpture" exhibition at the Museum of Modern Art in 1967.

The themes of nuclear power and warfare have engaged artists for some twenty years.[67] Perhaps the first important work on the subject was Henry Moore's *Nuclear Energy,* 1967 (fig. 78), which celebrates the twenty-fifth anniversary of the first sustained and controlled nuclear reaction on the campus of the University of Chicago in 1942. As the title and optimistic form of the work indicate, Moore's piece suggests the potential benefits of the atom and the ability of mankind and science to harness nuclear power for positive purposes. James Rosenquist commented more ironically on the nuclear issue in his enormous painting *F-111* (fig. 79), a detail of which shows a mushroom-shaped cloud beneath a beach umbrella, implicitly suggesting the fallacies of optimism concerning the atom's virtues.

As nuclear weaponry becomes more widespread and political rhetoric grows increasingly cavalier, many artists have committed themselves to the issue. The installations of Edward Kienholz and the "Firestorm" drawings of Robert Morris are particularly eloquent statements; however, much nuclear art has been obtuse and vague, as though the purposes of art and politics cannot be fused. This is partially due to a legacy of intellectualized concerns based in the Pop, Minimalism, and Conceptualism of previous decades that is shared by artists of the 1980s. While many contemporary artists believe passionately in the need for a politically committed art, their forms—

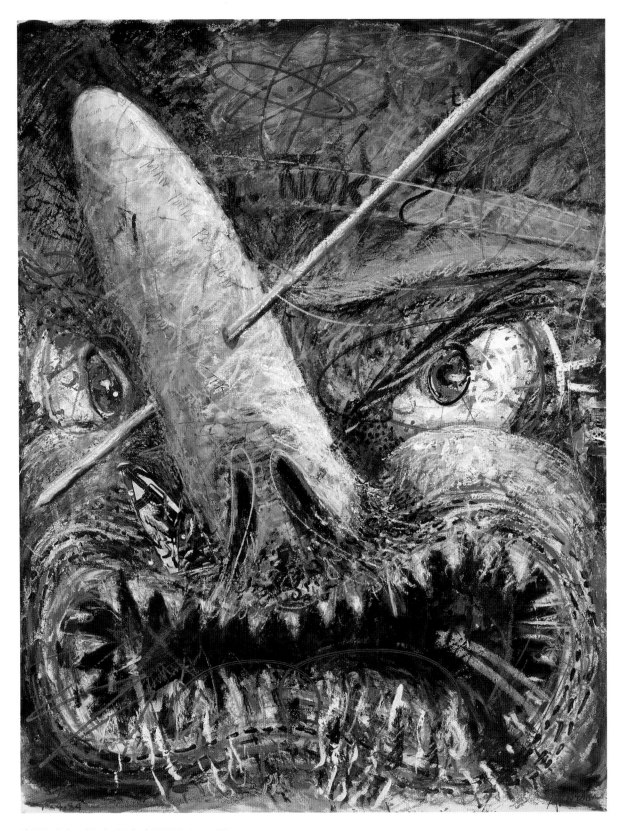

Pl. XX. *Colonel Nuke Pricked*, 1984 [cat. no. 68].

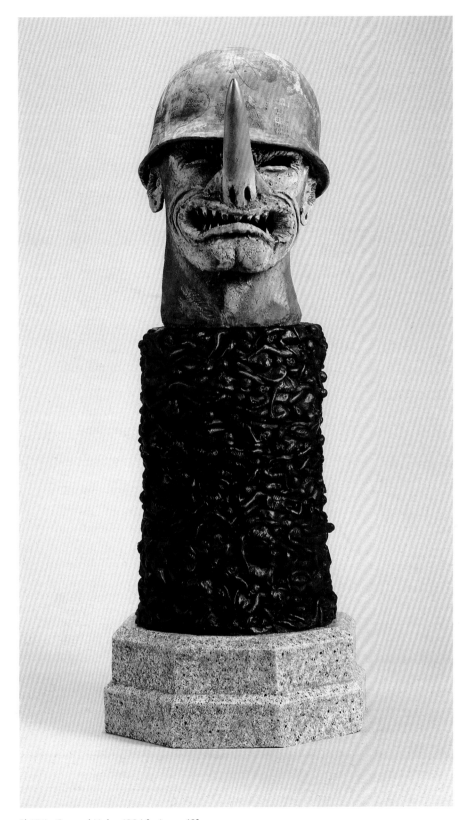

Pl. XXI. *General Nuke*, 1984 [cat. no. 42].

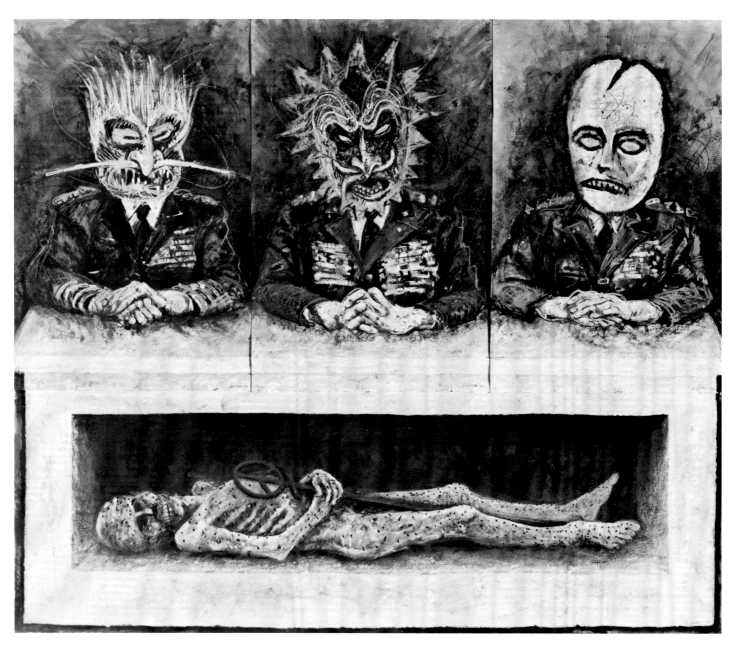

Fig. 81. *Joint*, 1984 [cat. no. 67].

Fig. 82. *Study for Johns,* 1964 [cat. no. 44].

installation, video, serial image photography, and other conceptual modes devised by their forerunners—have often emasculated their statements. With the exception of Morris and Kienholz, there is little contemporary art with the depth of reference and purpose, both formal and graphic, that Arneson's possesses; and none has the powerful personal immediacy of his wrenching heads.

A fundamental element of Arneson's artistic character is his pre-occupation with extending the boundaries of art. This was precisely his method early in his career, when he used biting satire and wit to battle the potter's lobby. In his most recent works, Arneson has been more forceful, and even propagandistic, effectively testing the art world's willingness to allow blatantly political themes within its sanctuary.

Typical of this approach is *Federal Emergency Mangement Agency,* 1984 (fig. 80) which analogizes the military bureaucracy to a wild-eyed carnivorous beast. Supplementing and even overwhelming the drawn image are numerous collaged photographs and graphics dealing with nuclear weaponry and military jingoism. The largest of the recent drawings is *Joint,* 1984 (fig. 81). Based on a news magazine photograph of three smiling generals seated at a press briefing, Arneson's image transforms the faces into mask-like caricatures; the medals on their chests drip blood, and before them is a sarcophagus occupied by a prone corpse. Arneson's most effective drawing in this vein is *Colonel Nuke Pricked,* 1984 (pl. XX), portraying a fanged, phallic-nosed archetypal villain invented by the artist. It should be noted that a sculpture, *General Nuke,* 1985 (pl. XXI) evolved from the drawing, with a similar head surmounting a bronze pedestal of embedded corpses, a concept Arneson derived from photographs of holocaust victims.

A distinction can be made between Arneson's most recent political works and his images from the early 1980s. Whereas the earlier "war heads" focused on the victims of nuclear holocaust, the recent works concentrate on imaginary military leaders who are the perpetrators of nuclear proliferation. The shift in emphasis can be partly

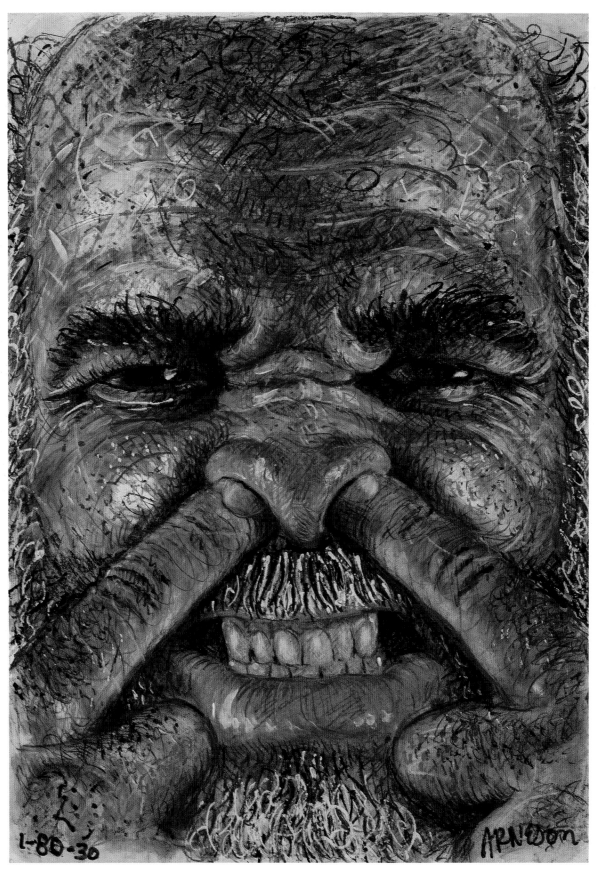

Pl. XXII. *Two Finger Job,* 1980 [cat. no. 57].

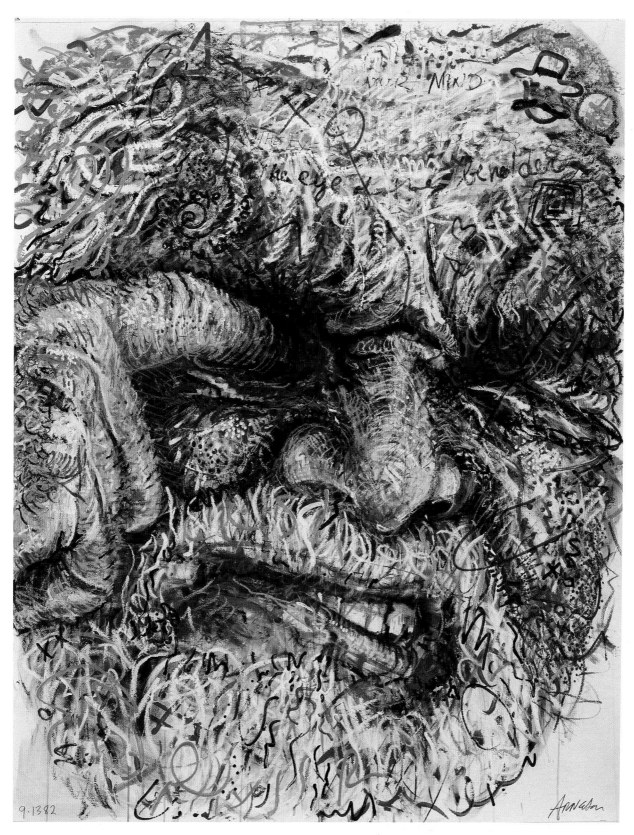

Pl. XXIII. *Eye of the Beholder,* 1982 [cat. no. 60].

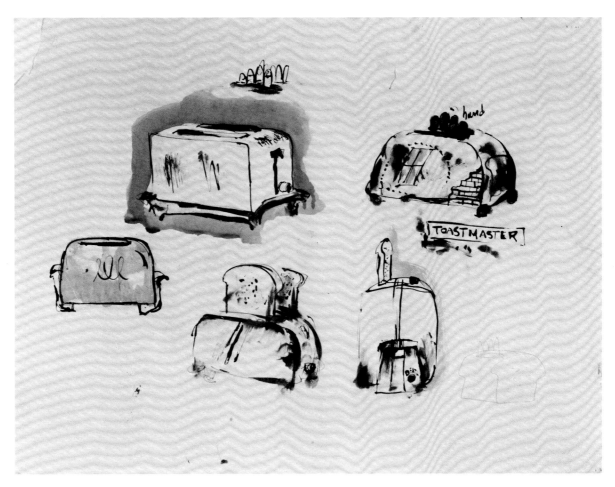

Fig. 83. *Toastmaster*, 1964 [cat. no. 45].

attributed to a change in the circumstances of the artist's health. Depressed by the disease that regimented his life for nearly ten years, Arneson recently underwent an experimental operation that has successfully removed and cured his cancer. The impact on the man has been striking, and his revitalization is clearly visible in the outspoken aggressiveness of these recent drawings.

In light of the power of Arneson's recent works on paper, a word must be added both about their quality and their relationship to the sculpture. Although drawing and cartooning occupied him in his youth, Arneson virtually stopped drawing when he committed himself to pottery in the mid-1950s. He only began to draw again in the early 1960s; and when he joined the faculty at Davis, Arneson made extensive use of the slide library, making color xeroxes from slides and then drawing after these copies.[68] His first drawing to relate to a sculpture was a rough, ink study of toilets in which tanks metamorphose into torsos and bowls become buttocks (fig. 82). The drawings of the 1960s—images of toilets and toasters, as well as his self-portrait studies (figs. 83 and 84)—served a primarily conceptual function as the sculptor planned his work through sketchy notations that were generally small in scale and intrinsically unambitious.

Arneson continued to use drawing as a preparatory tool through the mid-1970s. While most of the images of these years are directly related to specific sculptures, the studies for portraits of Picasso, Duchamp, and others can be seen as attempts to exorcise his subjects' influence over him.

Around 1980, drawing began to assume a new prominence in Arneson's work. Not only were such drawings as *Frontal* (fig. 86) and *Two Finger Job* (pl. XXII) not preparatory to sculptures, these images demonstrate remarkable formal and expressive development. Pressed to the edge of the page and against an imaginary frontal picture plane, each drawing becomes a swirling mesh of conte crayon. Like Impressionist brushstrokes, form dissolves on close inspection and the lack of spatial reference further enhances the abstract beauty of Arneson's line. The artist is quick to credit van Gogh and Pollock for influencing his approach to drawing, and both artists have been the subject of portrait homages on paper and in clay; van Gogh as early as 1977 (fig. 87) and Pollock on numerous occasions in 1983 (fig. 85; pl. XXIV).[69]

It is with the recent drawings on nuclear themes that Arneson's full maturity as a draughtsman is seen. Such images as *Joint* and

Fig. 84. *Self-Portrait Studies*, 1964 [cat. no. 46].

Colonel Nuke Pricked summarize many of the significant moments in Arneson's career: the obsessiveness of the childhood battle scenes; the cartoonist's wedding of word and image; the rapid pace of the conte crayon self-portraits; and the graffiti-like notations on the pedestals of many of his sculptures. It should be noted, as well, that the spontaneity with which Arneson draws yields immediate fulfillment; thus, these works serve an important creative function for the artist as a respite from the slow process of making a sculpture in clay.

In the past twenty-five years, Robert Arneson has transformed himself from a crafts fair potter to a sculptor and draughtsman of international stature. Having begun as a potter and having responded initially to progressive developments in the field of clay sculpture, Arneson maintained a degree of innocence into the 1960s. During a period characterized by formalism, Arneson developed into an iconoclast, obsessed with content and suspicious of any art which relied solely on formal accomplishment for its meaning.

Arneson's breakthrough came in the early 1970s, when he began to explore the expressive possibilities of portraiture, breathing new life into this largely abandoned art form. After his bout with cancer in the mid-1970s and the rejection of his Moscone bust in

1981, Arneson's iconoclasm assumed a heightened purposefulness. In the images of nuclear catastrophe that followed, Arneson transformed and redirected his former humor, achieving an art of savage power and political meaning.

Werner Hofmann has described the art of caricature as one of "scepticism," which, despite its seemingly innocuous appearance and conventional methods of representation, is the product of an iconoclastic mind in opposition to established doctrines and dogmas.[70] Holding nothing sacred, Arneson is perhaps the ultimate artist-iconoclast of our period, whether he is putting a top on a ceramic bottle, "capping" the potter's tradition of vessel production, or is applying pictorial perspective to sculpture, countering the prevailing Renaissance tradition of artistic illusionism. If contempt for a world of exaggerated and impossible ideals characterizes Arneson's career, this contempt has resulted in an unmistakable and explicit form of expression. Rather than mocking the world as it is or appears to be, Arneson reveals a macabre world of demons and death. Like the aging Goya, Arneson has moved from subtle and witty humor to uncompromisingly expressive personal and political imagery.

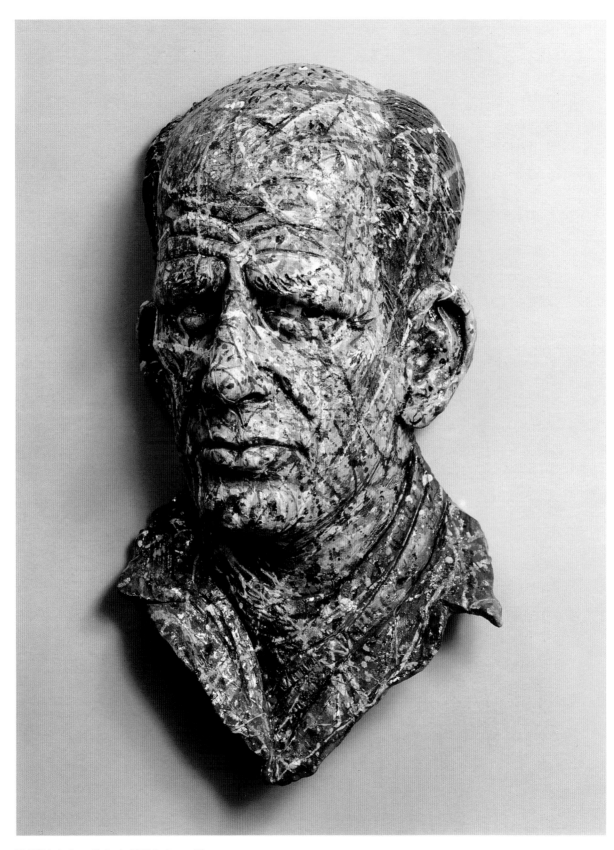

Pl. XXIV. *Jackson Pollock*, 1983 [cat. no. 41].

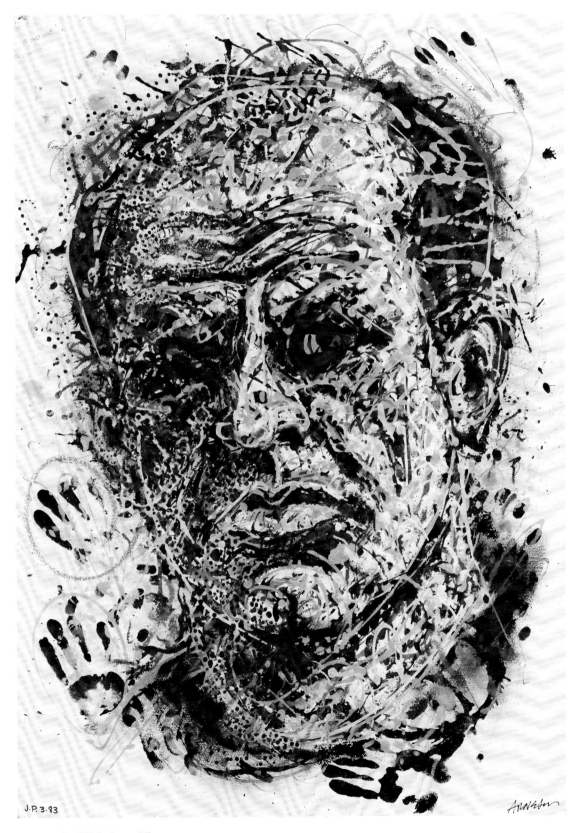

J.P. 3.83

ARNESON

Fig. 85. *J.P.*, 1983 [cat. no. 66].

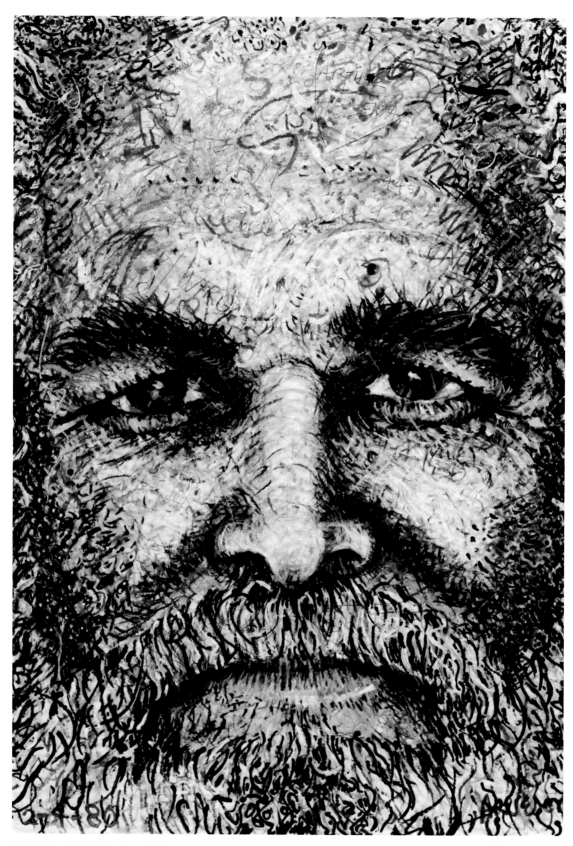

Fig. 86. *Frontal*, 1980 [cat. no. 54].

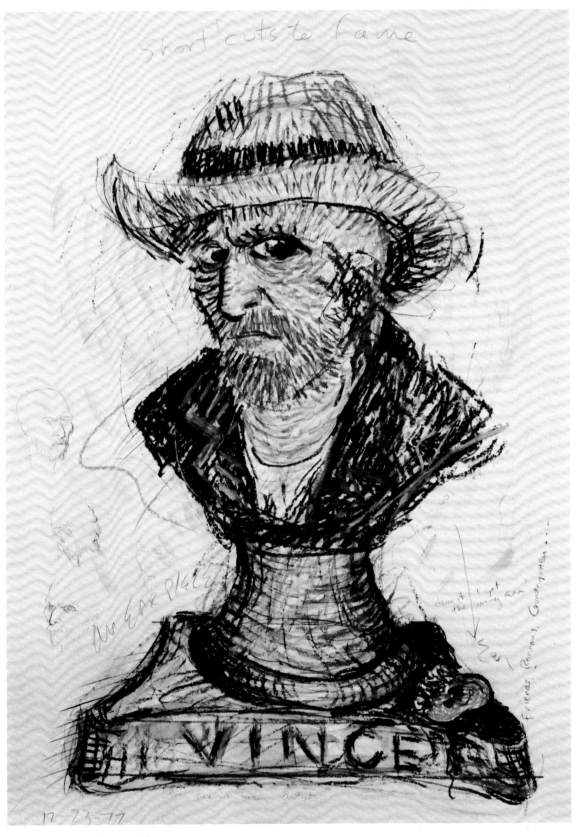

Fig. 87. *Vince*, 1977 [cat. no. 50].

Notes

1

From a series of tape recorded conversations with Arneson conducted by Maddie Jones in 1978. These tapes are in the possession of the Archives of American Art, San Francisco and the Richard L. Nelson Gallery, University of California, Davis. I am indebted to Robert Arneson and L. Price Amerson, Jr., Director of the Nelson Gallery, for making these tapes available to me. Except where noted, all subsequent statements by the artist are from these tapes.

2

"Befouling the Moscone Center," *San Francisco Examiner* (4 December 1981), B2.

3

Robert Arneson quoted in Susan Ager, "Moscone Sculptor Weary of the Whole Thing," *San Jose Mercury* (9 December 1981), 10F.

4

The first important American university curriculum in ceramics was developed in Alfred, New York, by Charles F. Binns at the beginning of the century. The College of Ceramics at Alfred University, State University of New York, as it is known today, offers the pre-eminent formal course in ceramics, a comprehensive training in the technology and design of pottery. For the history of ceramic education in the United States, and particularly the Alfred University tradition, see Paul S. Donnhauser, *History of American Ceramics,* Dubuque, Iowa, 1978. For Herbert Sanders, who was educated in this tradition at Ohio State University, see "Northern California," *Craft Horizons* 16 (September/October 1956), 32.

5

See Oppi Untracht, "Edith Heath Creates Textures on the Wheel," *Ceramics Monthly* 6 (March 1958), 18-21; and 6 (May 1958), 12-15.

6

Voulkos was the subject of a retrospective at the Museum of Contemporary Crafts, New York (now the American Craft Museum) in 1978. See Rose Slivka, *Peter Voulkos: A Dialogue with Clay,* New York, 1978. Other important publications of his work include: Conrad Brown, "Peter Voulkos," *Craft Horizons* 16 (September/October 1956), 12-18; Hal Fischer, "The Art of Peter Voulkos," *Artforum* 17 (November 1978), 41-47; and Whitney Museum of American Art, New York, "Ceramic Sculpture: Six Artists," 1981.

7

Often ignored, Picasso's clay sculpture was first shown in the United States at the Curt Valentin Gallery, "Pablo Picasso: Paintings, Sculpture, Drawings," in 1952. A much larger show, "Ceramics by Picasso," occurred at the Cooper Union in 1958, and this show was reviewed in *Artnews, Arts,* and *Craft Horizons* that same year. Arneson would introduce a pictorial essay on Picasso's sculpture in 1967. See below, note 32.

8

These events are chronicled in great detail in both *Ceramics Monthly* and *Craft Horizons,* beginning in April 1957. Of particular interest is Voulkos's statement on the work in the exhibition:

'Basically most things lacked any sense of involvement. They had a completely inhuman quality, such as a machine often turns out better. Idea was lacking, and in its place we suddenly saw the misleading term, craftsmanship . . . the favorite word in pottery circles throughout the country . . . I feel that craft groups become closed to the other vital arts. Can they not afford the luxury of looking at modern painting and sculpture?'

Quoted in "The Miami Annual," *Craft Horizons* 17 (May/June 1957), 42-43.

9

Robert Arneson quoted in "Letters," *Ceramics Monthly* 5 (July 1957), 4.

10

For Prieto, see "Antonio Prieto," *Design Quarterly* 42 (1958), 61; "He Set his Hand to Clay," *Mills Quarterly* 38 (February 1956), 3; and "Antonio Prieto 1912-1967," *Craft Horizons* 27 (July/August), 23-25.

11

"The Wichita Show," *Ceramics Monthly* 6 (September 1958), 17.

12

"Ceramic Sculpture by Robert Arneson," *Oakland Art Museum* (September/October 1960).

13

Alfred Frankenstein, "Painting to Pottery—San Francisco," *Art in America* 49 (1960, no. 1), 133.

14

Robert Arneson quoted in Museum of Contemporary Crafts, N.Y., "Clayworks: 20 Americans," 1971, unpaginated.

15

Johns's *Painted Bronze (Ale Cans)* was first reproduced in D.G. Seckler, "Folklore of the Banal," *Art in America* 50 (Winter 1962), 58.

16

I am indebted to Dorothy Franks of the Asian Art Museum, Fine Arts Museums of San Francisco, for this information.

17

Miró's work in clay was featured in Dore Ashton, "Miró-Artigas," *Craft Horizons* 17 (February 1957), 16-20; Hugo Weiss, "Miró—Magic with Rocks," *Artnews* (Summer 1956), 49-50; 56-58; and numerous works were included in the major retrospective, Museum of Modern Art, New York, "Joan Miró," 1959.

18

Rose Slivka, "The New Ceramic Presence," *Craft Horizons* 21 (July/August 1961), 30-37.

19

The history of the Department of Art at the University of California, Davis, is chronicled in two exhibition catalogues: Nelson Gallery and Memorial Union Art Gallery, University of California, Davis, "Sculptors at U.C. Davis," 1982; and Nelson Gallery, "Painters at U.C. Davis," 1984. I am again indebted to Price Amerson for his assistance.

20

"Robert Arneson in conversation with Rene diRosa," 1981. Tape in the possession of the Nelson Gallery, Davis, courtesy of Price Amerson.

21

Arneson worked somewhat extensively, though generally unsuccessfully, in bronze in his first years at Davis. His interest was not unusual, as there was an important but short-lived renaissance of bronze casting in the Bay Area during the early 1960s. As noted by Joseph A. Pugliese, "Casting in the Bay Area," *Artforum* 2 (August 1963), 11-14, the activity centered around Peter Voulkos and Harold Paris at University of California, Berkeley.

22

John Coplans, "Sculpture in California," *Artforum* 2 (August 1963), 3-6; and Anita Ventura, "Field Day for Sculptors," *Arts* 38 (October 1963), 62-65.

23

Robert Arneson in conversation with the author, 8 May 1984.

24

Robert Arneson in conversation with the author, 4 July 1985. The following discussion derives from Thomas Albright, *Art in the San Francisco Bay Area 1945-1980,* Berkeley, 1985, chapters 2-6.

25

In conversation with the author on 3 July 1985, William T. Wiley confirmed this notion, emphasizing the attitude of freedom which prevailed in the Bay Area in the 1950s and 1960s as a result of the influence of Still's and Rothko's iconoclastic attitudes.

26

William T. Wiley, quoted in Albright, *Art in the San Francisco Bay Area 1945-1980,* 119.

27

The term "Funk" art was coined by Peter Selz, as the title of an exhibition held at the University Art Museum, Berkeley in 1967. As has often been noted, the term was somewhat misleading, as it had already been employed in the 1950s to describe the work of an earlier generation of artists, such as Bruce Conner, Wally Hedrick, and others. Thomas Albright's distinction between funk (Conner, Hedrick, etc.) and Funk (Arneson, Wiley, etc.) is the best yet proposed. In addition to the catalogue of Selz's University Art Museum exhibition, see Albright, *Art in the San Francisco Bay Area,* 1985, 126-127; Harold Paris, "Sweet Land of Funk," *Art in America* 55 (March-April 1967), 95-98; and James Monte, "'Making It' with Funk," *Artforum* V (Summer 1967), 56-59.

28

The phrase "trust yourself" derives from two interviews: William T. Wiley in conversation with the author, 3 July 1985, and Robert Arneson in conversation with the author, 4 July 1985. Arneson used the term "jolted" in the following statement:

'But making my first toilet really jolted me. It jolted me because I am doing something—well—doing something that you know is in bad taste. These are no-no's. And yet—no one has ever done it. It has no art tradition.'

Robert Arneson quoted in Cecile N. McCann, "About Arneson, Art and Ceramics," *Artweek* (26 October 1974), 6.

29

James Melchert in conversation with the author, 8 May 1984.

30

Arneson has long rejected the formalist doctrine of sculpture as consisting of planes, volumes, and masses. Throughout the 1970s he pressed his self-portraits—both sculptures and drawings—against an imaginary frontal plane, thereby mocking formalist doctrine while contorting his face humorously. As he has noted:

'My work is not about sculpture in the traditional sense, volumes and planes, I am not working with clay like a sculptor, I am making drawings and paintings in space.'

Quoted in Cecile N. McCann, "About Arneson, Art and Ceramics," *Artweek* (26 October 1974), 1.

31

Robert Arneson in conversation with the author, 4 February 1985. Among Andrea della Robbia's most complex polychrome sculptures is an altarpiece in the Chiesa Maggiore in La Verna, which measures fifteen feet in height and consists of some 180 terracotta segments.

32

Arneson was the author of a brief introduction to a pictorial essay on Picasso's sculpture published on the occasion of this exhibition: "Picasso the Craftsman," *Craft Horizons* 27 (November-December 1967), 28-33.

33

Robert Arneson in conversation with the author, 4 February 1985.

34

Janet Malcolm, "On and Off the Avenue: About the House," *The New Yorker* (4 September 1971), 59.

35

Robert Arneson in conversation with the author, 8 May 1985.

36

Roy De Forest in conversation with the author, 1 February 1985.

37

I am indebted here to my colleague at The Art Institute of Chicago, Ian Wardropper.

38

Quoted in "Civilizations," John Michael Kohler Arts Center, Sheboygan, Wisconsin, 1977, 12.

39

Hilton Kramer, "Sculpture—From Boring to Brilliant," *New York Times* (15 May 1977), D27.

40

Roy of Port Costa was the last portrait bust to be modeled from Arneson's own image. Translating the generic self-portrait to a portrait of someone else proved too time-consuming, and it was at this point that Arneson developed a universal mold he continues to use for portrait busts. Robert Arneson in conversation with the author, 4 July 1985.

41

Superior studies of the history and nature of caricature are: E.H. Gombrich and Ernst Kris, *Caricature,* Harmondsworth, England, 1940; and Werner Hofmann, *Caricature: From Leonardo to Picasso,* New York, 1957. On the more general subject of humor in art, see Sigmund Freud, *Wit and its Relation to the Unconscious,* London, 1916; Ernst Kris, *Psychoanalytic Explorations in Art,* New York, 1952; and William Feaver, *Masters of Caricature,* London, 1981.

42

For Messerschmidt see Kris, *Psychoanalytic Explorations in Art,* New York, 1952, chapter 4; and, for Daumier, Jeanne L. Wasserman, *Daumier Sculpture,* Greenwich, Connecticut, 1969.

43

Hilton Kramer, "Ceramic Sculpture and the Taste of California," *New York Times* (20 December 1981), 31, 33.

44

William T. Wiley in conversation with the author, 3 July 1985.

45

White's action was prompted by Moscone's decision not to reappoint him to the supervisorial position which he had resigned only a few days earlier. The discussion that follows derives from accounts in the *San Francisco Chronicle* and the *San Francisco Examiner,* as well as *Time* and *Newsweek,* between 1978-1981.

46

"Getting Off?," *Time* (28 May 1979), 57.

47

Melinda Beck and Michael Reese, "Night of Gay Rage," *Newsweek* (4 June 1979), 30-31.

48

Diane Feinstein to Robert Arneson, 6 March 1981. Letter and accompanying contract in the possession of the artist. The history of the Moscone commission has been detailed previously by Suzaan Boettger, "Civic Art and City Politics," *Artweek* (23 January 1982), 3; Thomas Albright, "In Memoriam, In Storage," *Artnews* 81 (February 1982), 13; and Milwaukee Art Museum, "Controversial Public Art: From Rodin to di Suvero," 1983-84, 56-58.

49

Robert Arneson in conversation with Suzaan Boettger, 28 December 1981, 1-2, typescript courtesy of the artist.

50

Ibid., 2.

51

Ibid.

52

"Befouling the Moscone Center," *San Francisco Examiner* (4 December 1981), B2.

53

Diane Feinstein to the San Francisco Art Commission, 4 December 1981.

54

It should be noted that the Commission rejected Katherine Porter's proposed mural *Winds of the People* because it deviated from the artist's initial proposal.

55

For a discussion of this subject see, Milwaukee Art Museum, "Controversial Public Art: From Rodin to di Suvero," 1983-84.

56

Ibid., 53-55.

57

Kramer (note 43), 33.

58

Ibid.

59

Robert Arneson in conversation with the author, 4 July 1985.

60

Robert Arneson in conversation with Suzaan Boettger, 28 December 1981, 6-7, typescript courtesy of the artist.

61

Allan Frumkin in conversation with L. Price Amerson, Jr., February 1981, typescript in the collection of the Nelson Gallery, University of California, Davis.

62

Robert Arneson in conversation with the author, 4 February 1985.

63

Kramer (note 43), 33.

64

Arneson's comments on his illness derive from a conversation with the author, 4 July 1985. I am indebted to Thomas F. Worthen for his suggestions regarding Etruscan funerary sculpture.

65

This discussion of ceramic processes derives from the author's conversation with Robert Arneson, 4 July 1985.

66

Arneson (note 32), 28-33.

67

Two recent exhibitions treat this subject: Mount Holyoke College Art Museum and University Gallery, University of Massachusetts, Amherst, "The Shadow of the Bomb," 1984; and "Disarming Images: Art for a Nuclear Disarmament," circulated by The Art Museum Association of America, 1984-1986.

68

Robert Arneson in conversation with the author, 4 July 1985.

69

Robert Arneson in conversation with the author, 4 February 1985.

70

Werner Hofmann, *Caricature: From Leonardo to Picasso*, New York, 1957, 21-22.

Catalogue of the Exhibition

Dimensions are listed height x width x depth

Sculpture

1
No Deposit, No Return, 1961, glazed ceramic, 10¾ x 5 x 5″, collection of Mr. and Mrs. Paul C. Mills. [fig. 9]

2
Sign Post, 1961, glazed ceramic, 28¼ x 16 x 6¾″, Richard L. Nelson Gallery and the Fine Arts Collection, University of California, Davis; gift of Fay Nelson. [fig. 11]

3
Noble Image, 1961, glazed ceramic, 31 x 18½ x 8½″, collection of Robert Arneson and Sandra Shannonhouse. [fig. 12]

4
Untitled, 1963, glazed ceramic, 17 x 40 x 20″, collection of Robert Arneson and Sandra Shannonhouse. [fig. 13]

5
Study for a Gargoyle, 1963, glazed ceramic, 34 x 16½ x 13″, San Francisco Museum of Modern Art; William L. Gerstle Fund Purchase. [fig. 14]

6
John with Art, 1964, glazed ceramic with polychrome epoxy, 34½ x 18 x 25½″, Seattle Art Museum; gift of Manuel Neri. [fig. 19]

7
Heart Memorial Trophy, 1964, glazed ceramic, 27 x 19 x 9″, collection of Robert Arneson and Sandra Shannonhouse. [pl. II]

8
Toaster, 1965, glazed ceramic, 6 x 11 x 7″, collection of Allan Stone. [fig. 24]

9
Self-Portrait of the Artist Losing His Marbles, 1965, glazed ceramic and marbles, 31 x 17½ x 9½″, American Craft Museum; gift of the Johnson Wax Company from "Objects: U.S.A." [pl. IV]

10
Two-Bit Artist, 1965, 18″ (diameter), aluminum, private collection. [fig. 31]

11
Call Girl, 1966, glazed ceramic and sculpt-metal, 18 x 9 x 7½″, collection of Diana Fuller. [fig. 20]

12
Typewriter, 1966, 6 x 11½ x 12½″, glazed ceramic, courtesy Allan Stone Gallery. [fig. 25]

13
Kiln Man, 1971, glazed ceramic, 36 x 12 x 12″, Jedermann Collection, N.A. (exhibited in Des Moines and Washington, D.C. only). [fig. 37]

14
Smorgi-Bob, the Cook, 1971, ceramic with vinyl tablecloth and wood table, 73 x 66 x 53″, San Francisco Museum of Modern Art. [fig. 30]

15
Classical Exposure, 1972, ceramic, 93 x 36 x 24″, collection of Mr. and Mrs. Daniel Fendrick (exhibited in Washington, D.C. only). [fig. 36]

16
Fragment of Western Civilization, 1972, ceramic, 41 x 120 x 120″, Australian National Gallery, Canberra. [pl. V]

17
Assasination of a Famous Nut Artist, 1972, glazed ceramic, 30 x 22 x 13″, collection of Ross Turk. [fig. 35]

18
Blown, 1973, glazed ceramic, 15 x 21 x 17″, collection of the Lannan Foundation. [fig. 38]

19
Current Event, 1973, glazed ceramic, 9 x 175 x 85″, Stedelijk Museum, Amsterdam. [pl. VI]

20
The Palace at 9 a.m., 1974, glazed ceramic, 24 x 118 x 84″, Allan Frumkin Gallery. [pl.III]

21
Balancing Act, 1974, ceramic, 42 x 13½ x 13½″, private collection. [fig. 39]

22
George and Mona in the Baths of Coloma, 1976, glazed ceramic, 25 x 60 x 32″, Stedelijk Museum, Amsterdam. [fig. 49]

23
Roy of Port Costa, 1976, glazed ceramic, 34 x 18¾ x 18¾″, collection of Sydney and Frances Lewis. [fig. 45]

24
Kiown, 1978, glazed ceramic, 37 x 19 x 19″, Des Moines Art Center; Coffin Fine Arts Trust. [pl. VIII]

25
Rrose Selavy, 1978, glazed ceramic, 41 x 19 x 19″, collection of the Honorable Steven D. Robinson. [fig. 52]

26
Mr. Unatural, 1978, glazed ceramic, 53½ x 22 x 22″, private collection. [fig. 47]

27
Captain Ace, 1978, glazed ceramic, 44¾ x 24 x 18¾″, Stedelijk Museum, Amsterdam. [fig. 63]

28
Peter Voulkos, 1979, glazed ceramic, 17 x 14 x 7½″, collection of Byron and Eileen Cohen. [fig. 50]

29
Casualty in the Art Realm, 1979, glazed ceramic, 8 x 97 x 132″, courtesy of Robert Arneson and Fuller Goldeen Gallery. [pl.XI]

30
Pablo Ruiz with Itch, 1980, glazed ceramic, 87½ x 49½ x 42½″, Nelson-Atkins Museum of Art; gift of the Friends of Art. [pl. XII]

31
Squint, 1980, glazed ceramic, 74 x 22 x 22″, collection of John and Mary Pappajohn. [pl. IX]

32
Homage to Philip Guston (1913-1980), 1980, glazed ceramic, 11½ x 16 x 38″ (left shoe); 13½ x 18 x 42½″ (right shoe), collection of Martin Sklar. [pl. X]

33
Mr. Hyde, 1981, glazed ceramic and marbles, 13½ x 11 x 4½″, collection of Andy and Ginny Lewis. [fig. 44]

34
Portrait of the Artist as a Clever Old Dog, 1981, glazed ceramic, 34″ h. (other dimensions vary), collection of Florence and Marvin Gerstin. [fig. 73]

35
Self-Portrait with Bio-Base, 1982, bronze and glazed ceramic, 68 x 18½ x 18½″, collection of Robert Arneson and Sandra Shannonhouse. [fig. 75]

36
Ass to Ash, 1982, glazed ceramic, 84 x 28 x 28", Robert Arneson and Allan Frumkin Gallery. [pl. XVII]

37
California Artist, 1982, glazed ceramic, 68¼ x 27½ x 20¼", San Francisco Museum of Modern Art; gift of the Modern Art Council. [pl. XV]

38
Head Mined, 1982-83, glazed ceramic, 76½ x 24 x 24", Robert Arneson and Allan Frumkin Gallery. [fig. 76]

39
Holy War Head, 1982-83, glazed ceramic, 72 x 28 x 28", collection of Rita and Irwin Blitt. [pl. XVI]

40
Ground Zero, 1983, bronze, 26 x 80 x 80", collection of Armin Sadoff. [pl. XVIII]

41
Jackson Pollock, 1983, glazed ceramic, 23 x 13 x 7", collection of Dr. Paul and Stacy Polydoran. [pl. XXIV]

42
General Nuke, 1985, granite, bronze, and glazed ceramic, 77 x 29 x 29", Robert Arneson and Fuller Goldeen Gallery. [pl. XXI]

Works on Paper

43
Untitled, 1961, mixed-media collage on paper, 12 x 15½", collection of Robert Arneson and Sandra Shannonhouse. [fig. 17]

44
Study for Johns, 1964, ink on paper, 25 x 15", collection of Robert Arneson and Sandra Shannonhouse. [fig. 82]

45
Toastmaster, 1964, ink on paper, 18½ x 24½", collection of Robert Arneson and Sandra Shannonhouse. [fig. 83]

46
Self-Portrait Studies, 1964, ink on paper, 19 x 25", collection of Robert Arneson and Sandra Shannonhouse. [fig. 84]

47
1303 Alice Street (Working on Alice), 1967-68, mixed-media collage on paper, 26 x 20", collection of Robert Arneson and Sandra Shannonhouse. [fig. 27]

48
Iconoclast, 1974, 30 x 22¼", mixed-media collage on paper, 30 x 22¼", collection of Mr. and Mrs. Daniel Fendrick. [fig. 62]

49
Study for Mr. Unatural, 1977, conte crayon on paper, 41½ x 30", Allan Frumkin Gallery. [fig. 48]

50
Vince, 1977, pastel and conte crayon on paper, 41½ x 30¼", collection of Joseph Raffael. [fig. 87]

51
Clown, 1978, conte crayon and collage on paper, 41⅝ x 29⅞", Des Moines Art Center; Director's Discretionary Fund from the Gardner and Florence Call Cowles Foundation. [fig. 41]

52
Rrose Selavy, 1978, conte crayon on paper, 40 x 31", collection of Gilda and Henry Buchbinder. [fig. 51]

53
Homage to Philip Guston, 1980, pastel, pencil, charcoal, and conte crayon on paper, 42 x 32", collection of the Prudential Insurance Company of America. [fig. 55]

54
Frontal, 1980, gouache, conte crayon, wash, and crayon on paper, 41½ x 29¾", Whitney Museum of American Art; gift of Nancy M. O'Boyle in honor of Flora Miller Irving. [fig. 86]

55
Drawing for Ikarus, 1980, oil stick, crayon, and pastel on paper, 29¹⁵⁄₁₆ x 52¾", collection of Mr. and Mrs. Harry W. Anderson. [pl. VII]

56
Pablo Ruiz with Itch, 1980, pastel, acrylic, ink, charcoal, and collage on paper, 42 x 42", Nelson-Atkins Museum of Art; gift of the Friends of Art. [fig. 53]

57
Two Finger Job, 1980, oil stick and acrylic on paper, 41½ x 30", collection of Martin Sklar. [pl. XXII]

58
Portrait of the Artist as a Clever Old Dog, 1981, conte, charcoal, collage, and mixed media on paper, 35 x 45", collection of Robert Arneson and Sandra Shannonhouse. [fig. 72]

59
Big George, 1981, conte crayon, oil pastel, and acrylic on paper, 52½ x 42", collection of the Capital Group, Inc. [pl. XIII]

60
Eye of the Beholder, 1982, acrylic, oil pastel, and alkyd on paper, 52 x 42", Allan Frumkin Gallery. [pl. XXIII]

61
Main Event, 1982, conte crayon, acrylic pastel, and oil on paper, 42 x 52", collection of W. Scott Woods. [fig. 69]

62
Harvey Milk, 1982, conte crayon, acrylic, and oil stick on paper, 30 x 22", collection of Robert Arneson and Sandra Shannonhouse. [pl. XIV]

63
The Fighter, 1982, conte crayon on paper, 40 x 40", collection of Harry Dennis and Michael McTwigan. [fig. 70]

64
California Artist, 1982, conte crayon, oil pastel, and collage on paper, 52 x 42", collection of Mr. and Mrs. A. J. Krisik. [fig. 71]

65
Gotcha, 1983, acrylic, oil stick, and alkyd on paper, 53 x 84", Hirshhorn Museum and Sculpture Garden. [pl. XIX]

66
J.P., 1983, oil stick and acrylic on paper, 41½ x 30", Allan Frumkin Gallery. [fig. 85]

67
Joint, 1984, oil stick and acrylic on paper, 75 x 90", Robert Arneson and Fuller Goldeen Gallery. [fig. 81]

68
Colonel Nuke Pricked, 1984, oil stick, acrylic, and collage on paper, 53 x 42", private collection. [pl. XX]

Chronology

1930
Born September 4 in Benicia, California, the son of Arthur and Helena Arneson.

1949
Graduated from Benicia High School.

1949-51
Attended College of Marin, Kentfield, California.

1949-52
Worked as sports cartoonist for *Benicia Herald*.

1952
Received scholarship to California College of Arts and Crafts, Oakland.

1954
Received B.A. degree from Arts and Crafts with major in Art Education.

1954-57
Taught at Menlo Atherton High School, Atherton, California.

1955
Married Jeanette Jensen.

1956
Studied ceramics during summer with Herbert Sanders at San Jose State College and Edith Heath at California College of Arts and Crafts.

1957-58
Studied ceramics with Tony Prieto at Mills College, Oakland; received M.F.A. in spring 1958.

1958-59
Taught at Santa Rosa Junior College, Santa Rosa, California.

1959-60
Taught at Fremont High School, Oakland.

1960-62
Taught design and crafts at Mills College, Oakland.

1962
Appointed Assistant Professor of Art and Design at University of California, Davis.

1967-68
Received Creative Arts Grant from University of California; spent academic year painting in New York.

1968
Taught summer school at University of Wisconsin, Madison.

Appointed Associate Professor, University of California, Davis.

1971
Received National Endowment for the Arts grant.

1973
Appointed Professor, University of California, Davis. Married artist Sandra Shannonhouse.

1975
Moved to Benicia.

Began series of lithographs at Landfall Press, Chicago.

1978
Received National Endowment for the Arts grant.

Traveled in France, Belgium, Holland, and Switzerland.

1981
Built new studio in Benicia.

Began ongoing work in bronze at Bronze Aglow Foundry, Walla Walla, Washington.

Began work in cast paper and woodcuts at Experimental Workshop, San Francisco.

1982
Traveled in Italy.

1984
Traveled in France.

1985
Awarded honorary doctorate from Rhode Island School of Design.

Selected Individual Exhibitions

1960
"Ceramics and Sculpture by Robert Arneson"
Oakland Art Museum, California

1962
"Robert Arneson: Ceramics, Drawings and
Collages" M.H. De Young Memorial
Museum, San Francisco

1963
"Recent Ceramic Sculpture" Richmond Art
Center, Richmond, California

1964
Cellini Gallery, San Francisco

Allan Stone Gallery, New York

1968
Galeria del Sol, Santa Barbara

Hansen Fuller Gallery, San Francisco

1969
Hansen Fuller Gallery, San Francisco

Allan Stone Gallery, New York

Candy Store Gallery, Folsom, California

1970
Hansen Fuller Gallery, San Francisco

Candy Store Gallery, Folsom, California

1971
Hansen Fuller Gallery, San Francisco

Candy Store Gallery, Folsom, California

1972
Hansen Fuller Gallery, San Francisco

Candy Store Gallery, Folsom, California

"Artworks" Manolides Gallery, Seattle,
Washington

1973
Hansen Fuller Gallery, San Francisco

1974
"Robert Arneson Retrospective" Museum of
Contemporary Art, Chicago (traveled to San
Francisco Museum of Modern Art)

Hansen Fuller Gallery, San Francisco

Deson-Zeks Gallery, Chicago

Candy Store Gallery, Folsom, California

1975
Hansen Fuller Gallery, San Francisco

Allan Frumkin Gallery, New York

Ruth Schaffner Gallery, Los Angeles

Candy Store Gallery, Folsom, California

1976
Hansen Fuller Gallery, San Francisco

Fendrick Gallery, Washington, D.C.

Memorial Union Art Gallery, University of
California, Davis, California

1977
Hansen Fuller Gallery, San Francisco

"Seven Monumental Heads" Allan Frumkin
Gallery, New York

1978
Allan Frumkin Gallery, Chicago

1979
"Robert Arneson: Self-Portraits" Moore
College of Art, Philadelphia

"Robert Arneson: Heroes and Clowns" Allan
Frumkin Gallery

1980
Fendrick Gallery, Washington, D.C.

Frumkin & Struve Gallery, Chicago

Hansen Fuller Goldeen Gallery, San Francisco

1981
"Robert Arneson: New Ceramic Sculpture"
Allan Frumkin Gallery, New York

1982
"The Alice Street Drawings, Paintings and
Sculpture, 1966–1967" Nelson Gallery,
University of California, Davis

Fuller Goldeen Gallery, San Francisco

1983
"War Heads and Others" Allan Frumkin
Gallery, New York

"Robert Arneson: Masks and Portraits"
Organized by Landfall Press, Inc., Chicago
(traveled to Wright Art Center, Beloit College,
Beloit, Wisconsin; Saginaw Art Museum,
Michigan; Springfield Art Museum, Missouri;
Performing Arts Center Gallery, Tulsa, Okla-
homa; Gallery Karl Oskar, Shawnee Mission,

Kansas; Ball State University Museum of Art,
Muncie, Indiana)

Yares Gallery, Scottsdale, Arizona

Crocker Art Museum, Sacramento, California

"Moscone Bust Exhibition" (traveled to Triton
Museum of Art, Santa Clara, California;
Crocker Art Museum, Sacramento, Califor-
nia; Fresno Art Center, California; Fountain
Gallery; Portland, Oregon).

1984
Allan Frumkin Gallery, New York

Fuller Goldeen Gallery, San Francisco

Frumkin & Struve Gallery, Chicago

1985
Fuller Goldeen Gallery, San Francisco

Selected Group Exhibitions

1962
"Adventures in Art" Seattle World's Fair, Washington

1963
"Creative Casting" Museum of Contemporary Crafts, New York

"California Sculpture" Kaiser Center, Oakland, California

1965
"New Ceramic Forms", Museum of Contemporary Crafts, New York

1966
"Ceramics from Davis" Museum West, American Craftsmen's Council, San Francisco

"California Ceramic Sculpture" Reed College, Portland, Oregon

1967
"Funk" University Art Museum, Berkeley, California

"Arts of San Francisco" San Francisco Museum of Art, California

1968
"Dada, Surrealism and Their Heritage" Museum of Modern Art, New York (traveled to Los Angeles County Museum of Art; The Art Institute of Chicago)

1969
"Objects U.S.A. — The Johnson Collection of Contemporary Crafts" National Collection of Fine Arts, Smithsonian Institution, Washington, D.C.

"Human Concern-Personal Torment: The Grotesque in American Art" Whitney Museum of American Art, New York

"Ceramic Sculpture" Hansen Fuller Gallery, San Francisco

"The Spirit of the Comics" Institute of Contemporary Art, University of Pennsylvania, Philadelphia

"Bob and Roy Ceramics" Esther Robles Gallery, Los Angeles

"Drawings" Fort Worth Art Museum, Texas

1970
"Annual Exhibition: Contemporary American Sculpture" Whitney Museum of American Art, New York

"San Francisco Art Institute Centennial Exhibition" M.H. De Young Memorial Museum, San Francisco

"Ceramics '70" Everson Museum of Art, Syracuse, New York

1971
"Clayworks: 20 Americans" Museum of Contemporary Crafts, New York

"Contemporary Ceramic Art: Canada, USA, Mexico and Japan" National Museum of Modern Art, Kyoto (traveled to National Museum of Modern Art, Tokyo, 1972)

1972
"A Decade of Ceramic Art, 1962-1972: From the Collection of Professor and Mrs. R. Joseph Monsen" San Francisco Museum of Art, California

1973
"Painting and Sculpture by Young American Artists" Cranbrook Academy of Art Gallery, Bloomfield Hills, Michigan

1974
"The Fred and Mary Marer Collection: 30th Annual Ceramics Exhibition" Lang Art Gallery, Scripps College, Claremont, California

"Clay" Whitney Museum of American Art, Downtown Branch, New York

"Bay Area Ceramics" Allan Frumkin Gallery, New York

1975
"Sculpture: American Directions, 1945-1975" National Collection of Fine Arts, Smithsonian Institution, Washington, D.C.

"Clay U.S.A." Fendrick Gallery, Washington, D.C.

1976
"Painting and Sculpture in California: The Modern Era" San Francisco Museum of Modern Art (traveled to National Collection of Fine Arts, Smithsonian Institution, Washington, D.C.)

1977
"Sculpture: American Directions 1945-75" National Collection of Fine Arts, Smithsonian Institution, Washington, D.C.

"The Object as Poet" Renwick Gallery of the National Collection of Fine Arts, Smithsonian Institution, Washington, D.C.

"Contemporary Ceramic Sculpture" Ackland Art Center, University of North Carolina, Chapel Hill

1978
"Nine West Coast Sculptors" Everson Museum of Art, Syracuse, New York, (traveled to Arts and Crafts Center, Pittsburgh, Pennsylvania)

1979
"A Century of Ceramics in the United States, 1878—1978" Everson Museum of Art, Syracuse, New York (traveled to Renwick Gallery of the National Collection of Fine Arts, Smithsonian Institution, Washington, D.C.)

"West Coast Ceramics" Stedelijk Museum, Amsterdam, The Netherlands

"Whitney Biennial" Whitney Museum of American Art, New York

1980
"Twenty American Artists" San Francisco Museum of Modern Art, California

1981
"Recent Drawing Acquisitions" Museum of Modern Art, New York

"Ceramic Sculpture: Six Artists" Whitney Museum of American Art, New York (traveled 1982 to San Francisco Museum of Modern Art)

"The Image in American Painting and Sculpture" Akron Art Museum, Ohio

"The Clay Figure" American Craft Museum, New York

1982
"100 Years of California Sculpture" The Oakland Art Museum, California

1983
"Ceramic Echoes" Nelson-Atkins Museum of Art, Kansas City

Selected Bibliography

"Controversial Public Art" Milwaukee Art Museum, Wisconsin

"Art Itinera 83: Painterly Drawings" (traveled in Italy to Castello; Pasquini; Volterra; Castiglioncello)

"The Sculptor as Draughtsman" Whitney Museum of American Art

1984
"The Sculptor as Draughtsman" Whitney Museum of American Art, New York

"Drawings Since 1974" Hirshhorn Museum and Sculpture Garden, Washington, D.C.

"Directions in Contemporary American Ceramics" Museum of Fine Arts, Boston

"California Sculpture Show" Fisher Gallery, University of Southern California, Los Angeles (traveled 1984–1985 to Musée d'art contemporain de Bordeaux, France; Städtische Kunsthalle, Mannheim, West Germany; Yorkshire Sculpture Park, West Bretton, England; Sonja Henies og Niels Onstads Stiftelser, Høvikodden, Norway)

"Disarming Images: Art for a Nuclear Disarmament" (circulated by The Art Museum Association of America, 1984–1986).

Adrian, Dennis, "Robert Arneson's Feats of Clay," Art in America 62 (September-October 1974), 80-83.

Albright, Thomas, "Mythmakers," The Art Gallery Magazine 18 (February 1975), 12-17, 44-45.

————, "Robert Arneson," Artnews 75 (March 1976), 88.

————, "A Familiar Laughing Face," San Francisco Chronicle (25 November 1977), 60.

————, "In Memoriam, In Storage," Artnews 81 (February 1982), 13-14.

————, "A Monumental Side of Arneson," San Francisco Chronicle (22 February 1984), 53.

————, Art in the San Francisco Bay Area: 1945-1980, Berkeley, 1985.

Andre, Michael, "Robert Arneson," Artnews 74 (April 1975), 93-94.

Armstrong, Lois, "Los Angeles: Roy De Forest and Robert Arneson," Artnews 68 (October 1969), 74-76.

Arneson, Robert, "Letters," Ceramics Monthly 5 (July 1957), 4.

————, "Letters," Artforum II (October 1963), 8.

————, "Picasso the Craftsman," Craft Horizons 27 (November-December 1967), 28-33.

————, My Head in Ceramics, Davis, 1972.

Baker, Kenneth, "Arneson Takes on Nuclear Threat," San Francisco Chronicle (9 November 1985), 36.

Ball, Fred, "Crocker Collection," Artweek 4 (1 September 1973), 3.

————, "A Decade of Ceramic Art: 1962-1972," Ceramics Monthly 21 (January 1973), 18-20.

————, "Arneson," Craft Horizons 34 (February 1974), 29-30, 63, 65.

————, "Fifty Years of Crocker Kingsley," Artweek 6 (26 April 1975), 5.

Ballatore, Sandy, "California Clay Rush," Art in America 64 (July 1976), 15.

Block, Jean Lipman, "Robert Arneson," Craft Horizons 36 (October 1976), 55.

Boettger, Suzaan, "Scenes from a Marriage," The Museum of California (July-August 1982), 11-14.

————, "Civic Art and City Politics," Artweek (23 January 1982), 3.

Bourdon, David, "Robert Arneson," Village Voice (3 March 1975), 92.

Brown, Christopher, "Bob Arneson—From Comic Books to Self-Portrait," Artweek 7 (16 October 1976), 3.

Cicansky, Victor, "Contemporary Ceramics II, Tokyo," Artscanada 29 (Spring 1972), 76-77.

Coffelt, Beth, "Delta Bob and Captain Ace," San Francisco Sunday Examiner and Chronicle (8 April 1979), 40-47 (California Living).

Cohen, R. H., "Clay at the Whitney," Arts 42 (February-March 1982), 31.

Coplans, John, "Sculpture in California," Artforum 2 (August 1963), 3-6.

Davis, Douglas, "Crock Art," Newsweek 78 (5 July 1971), 78.

Derfner, Phyllis, "Robert Arneson," Art International 19 (April 1975), 58.

Ellenzweig, Allen, "Robert Arneson," Arts 49 (April 1975), 14.

————, "Robert Arneson," Arts Magazine 52 (September 1977), 30.

Fineberg, Jonathan, "Robert Arneson: Pablo Ruiz with Itch," Harvard Magazine (January-February 1984), 28.

Fitzgibbon, John, "Sacramento!," Art in America 59 (November-December 1971), 78-83.

Frankenstein, Alfred, "Painting to Pottery—San Francisco," Art in America 49 (1960, no.1), 133.

————, "Of Bricks, Pop Bottles, and a Better Mousetrap," San Francisco Sunday Examiner & Chronicle (6 October 1974), 37 (This World Magazine).

_____, "The Ceramic Sculpture of Robert Arneson, Transformation of Craft into Art," *Artnews* 75 (January 1976), 48-50.

French, Christopher, "Raising the Stakes," *Artweek,* (16 November 1985), 1.

Glueck, Grace, "Art People: A Partner to His Kiln," *New York Times* (15 May 1981), C21.

Hobbs, Robert C., "Art as Social Comment," *The Iowa Alumni Review* 37 (September-October 1984), 18-20.

Irwin, James, "Censored Clay," *Ceramics Monthly* 30 (February 1982), 32-33.

Judd, Donald, "Robert Arneson," *Arts Magazine* 39 (January 1965), 69.

Kelley, Jeff, "Re Clay," *Arts Magazine* 56 (March 1982), 79.

Kramer, Hilton, "Sculpture—From Boring to Brilliant," *New York Times* (15 May 1977), section 2, 27.

_____, "Ceramic Sculpture and the Taste of California," *New York Times* (20 December 1981), 31, 33.

Kuspit, Donald, "Arneson's Outrage," *Art in America* 73 (May 1985), 134-139.

Last, Martin, "Robert Arneson," *Artnews* 68 (December 1969), 8.

Licka, C.E., "A Prime Facie Sampler: A Case for Popular Ceramics I," *Currant* 1 (August-September 1975), 3-34, 60.

Licka, C.E., "A Prima Facie Sampler: A Case for Popular Ceramics II," *Currant* 1 (October-November 1975), 8-13, 50-53.

Malcolm, Janet, "On and Off the Avenue: About the House," *The New Yorker* 47 (4 September 1971), 59-60.

Manger, Barbara, "Robert Arneson Retrospective," *Artweek* 5 (23 February 1974), 2.

Martin, Fred, "Robert Arneson," *Art International* 20 (March-April 1976), 80.

McCann, Cecile N., "About Arneson, Art and Ceramics," *Artweek* 5 (26 October 1974), 1, 6-7.

_____, "Arneson and Towbridge." *Artweek* 4 (20 October 1973), 3.

_____, "Arneson, Moses—A Study in Contrasts," *Artweek* 3 (14 October 1972), 2.

_____, "Arneson, Richardson," *Artweek* 1 (23 May 1970), 2.

McFadden, Sarah, "Robert Arneson," *Art in America* 65 (July 1977), 100.

McTwigan, Michael, "Prologue to a Present Master," *New Lazarus Review* (Spring 1978), 85-90.

Meisel, Alan R., "Robert Arneson," *Craft Horizons* 32 (February 1972), 44-45.

_____, "Robert Arneson," *Craft Horizons* 33 (February 1973), 59.

_____, "Robert Arneson," *Craft Horizons* 34 (December 1974), 17.

_____, "Robert Arneson," *Craft Horizons* 36 (April 1976), 15.

Nasisse, Andy, "Robert Arneson," *Craft Horizons* 36 (October 1976), 57.

Perone, Jeff, "Robert Arneson," *Artforum* 16 (September 1977), 75.

Perreault, John, "Robert Arneson," *Soho Weekly News* (6 March 1974), 17.

Phillips, D.C., "Robert Arneson," *Artnews* 80 (September 1981), 231.

Polley, Elizabeth M., "Robert Arneson: Richmond Art Center," *Artforum* 2 (January 1964), 9.

Pugliese, Joseph, "At Museum West: Ceramics at Davis," *Craft Horizons* 26 (November-December 1966), 26-29.

_____, "The Decade: Ceramics," *Craft Horizons* 33 (February 1973), 46-49, 76-77.

Raynor, Vivian, "Art: Ceramic Caricatures by Robert Arneson," *New York Times* (8 May 1981), C18.

Richardson, Brenda, "California Ceramics," *Art in America* 57 (May-June 1969), 104-105.

Schjeldahl, Peter, "Robert Arneson," *Artnews* 65 (Summer 1966), 10.

Schwartz, Barbara, "Robert Arneson," *Craft Horizons* 35 (August 1975), 44.

Slivka, Rose, "The New Ceramic Presence," *Craft Horizons* 21 (July-August 1961), 30-37.

_____, "Laugh-In in Clay," *Craft Horizons* 31 (October 1971), 39ff.

Sommer, Robert, "Comment: Arneson's Bust," *Arts and Architecture* 1 (August 1982), 14-16.

Stepan, R. F., "Arneson's Landscape," *Artweek* 7 (24 January 1976), 5.

Stiles, Knute, "San Francisco: Robert Arneson at Hansen Fuller Goldeen," *Art in America* 68 (September 1980), 132.

Stone, Gwen, "Robert Arneson in Conversation with Gwen Stone," *Visual Dialog* 2 (1977), 5-8.

Tarshis, Jerome, "Esthetic and Fiscal Progress," *Artnews* 72 (December 1973), 74.

_____, "Looking for Arneson to Get Serious," *California Magazine* (May 1985), 92-93, 128-129.

_____, "Playing Around," *Artnews* 73 (December 1974), 61.

Van Houten, David, "Bob Arneson: Take Notice," *Artweek* 6 (25 January 1975), 2.

Ventura, Anita, "Field Day for Sculptors," *Arts* 38 (October 1963), 62-65.

"The Wichita Show," *Ceramics Monthly* 6 (September 1958), 17.

Zack, David, "California Myth-Making," *Art and Artists* 4 (July 1969), 26-31.

_____, "The Ceramics of Robert Arneson," *Craft Horizons* 30 (January-February 1970), 36 ff.

_____, "Funk Art," *Art and Artists* 2 (April 1967), 36-39.

_____, "Nut Art in Quake Time," *Artnews* 69 (March 1970), 88-91.

Lenders to the Exhibition

Mr. and Mrs. Harry W. Anderson
Atherton, California

Robert Arneson and Sandra Shannonhouse
Benicia, California

Rita and Irwin Blitt,
Shawnee Mission, Kansas

Gilda and Henry Buchbinder
Chicago, Illinois

Byron and Eileen Cohen
Kansas City, Missouri

Harry Dennis and Michael McTwigan
New York, New York

Diana Fuller
San Francisco, California

Mr. and Mrs. Daniel Fendrick
Washington, D.C.

Florence and Marvin Gerstin
Bethesda, Maryland

Jedermann Collection, N.A.

Mr. and Mrs. A.J. Krisik
Carmichael, California

Andy and Ginny Lewis
Richmond, Virginia

Sydney and Frances Lewis
Richmond, Virginia

Mr. and Mrs. Paul C. Mills
Santa Barbara, California

John and Mary Pappajohn
Des Moines, Iowa

Dr. Paul and Stacy Polydoran
Des Moines, Iowa

Joseph Raffael
San Geronimo, California

Honorable Steven D. Robinson
Coral Gables, Florida

Armin Sadoff
Beverly Hills, California

Martin Sklar
New York, New York

Allan Stone
New York, New York

Ross Turk
Elkhart, Indiana

W. Scott Woods
San Francisco, California

Anonymous lenders

American Craft Museum
Australian National Gallery
Capital Group, Inc.
Des Moines Art Center
Allan Frumkin Gallery
Fuller Goldeen Gallery
Hirshhorn Museum and Sculpture Garden
The Lannan Foundation
Richard L. Nelson Gallery and the Fine Arts Collection,
 University of California, Davis
Nelson-Atkins Museum of Art
Prudential Insurance Company of America
San Francisco Museum of Modern Art
Seattle Art Museum
Stedelijk Museum
Whitney Museum of American Art

Trustees and Staff

Photography Credits

Robert Arneson, figs. 7, 18, 27, 39; Morris Benezra, fig. 78; Rudolph
Burkhardt, fig. 79; Geoffrey Clements, fig. 86; eeva-inkeri, figs. 52,
70, 73, 85, plates XX, XXII; M. Lee Fatheree, figs. 1, 2, 12, 13, 17, 20,
34, 40, 44, 55, 58, 60, 64, 68, 72, 76, 81, 82, 83, 84, plates I, II, VII,
IX, XVI; Phillip Galgiani, fig. 30; Jaroslaw Kobylecky, figs. 59, 61; Pam
Maddock, figs. 3, 11, pl. III; Jerry Mathiason, fig. 8; McIntosh &
Smith, Inc., fig. 39; Don Myer, fig. 4; Otto E. Nelson, figs. 22, 67; Joe
Nobody, figs. 42, 47, 51, 87; David Penney, fig. 28, plates IV, VIII;
Eric Pollitzer, figs. 16, 71; Quicksilver Photographers, figs. 36, 62;
Nathan Rabin, fig. 23; T. K. Rose, figs. 24, 25; Jerry L. Thompson,
fig. 21.